CELEBRATING
Old Friends

Stories from Kentucky's
Thoroughbred Retirement Farm

RICK CAPONE

Foreword by MARY SIMON | *Introduction by* MICHAEL BLOWEN

THE
History
PRESS

Published by The History Press
Charleston, SC
www.historypress.net

Cover images front and back courtesy of the author, except top back sunrise image, which is courtesy Carole Oates.

Opposite: Bill Mooney, *left*, stands with Michael Blowen in front of the Eclipse award (on the mantel) that Mooney donated to Old Friends. *Courtesy of author*.

First published 2017

Manufactured in the United States

ISBN 9781467137836

Library of Congress Control Number: 2017945012

Notice: The information in this book is true and complete to the best of our knowledge. It is offered without guarantee on the part of the author or The History Press. The author and The History Press disclaim all liability in connection with the use of this book.

This book is dedicated to Bill Mooney.

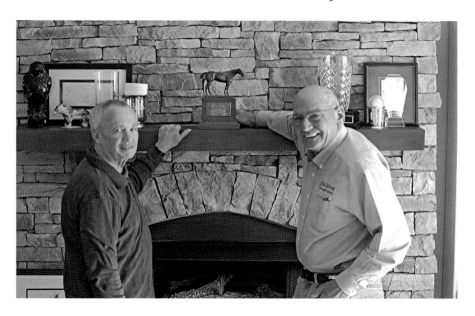

A good friend, supporter and the official eulogist of Old Friends.

CONTENTS

CONTENTS

FOREWORD

*H*orse racing has a well-documented, centuries-old history filled with great champions, wondrous feats and glorious pageantry. But there has long been another side to this public face, one that has caused many to view the "Sport of Kings" with suspicion. As the animal rights movement took wing in recent years, there has been growing concern over what happens to ex-racehorses that gave their all for our entertainment. Certainly, a lucky few enter stud each year at palatial farms, where they are treated like equine royalty, while others become broodmares, show or eventing horses, riding stock, companion animals and beloved pets. But to the sport's eternal shame, some of these former racetrack warriors embark on unhappy lives after their days of perceived usefulness are over—ending up in unspeakable situations of neglect, abuse and abandonment…with more than a few placed in vans headed to slaughter.

Thankfully, that has been changing, slowly and with the combined efforts of those at the forefront of the burgeoning Thoroughbred aftercare movement. Leaders of this movement, for the past decade and a half, included former Boston-based newspaper film critic Michael Blowen and his wife, award-winning columnist Diane White, who in 2003 followed a dream to Kentucky to establish the Old Friends retirement facility, with its unique emphasis on providing forever homes for aging stallions. Although some in the racing industry were initially skeptical of the concept, most have long since been won over—and then some.

FOREWORD

Among the ever-growing number of Old Friends supporters is author Rick Capone, whose idea for this book and its well-received predecessor, *The History of Old Friends: A Home for Retired Thoroughbreds*, germinated during a 2008 visit to the Georgetown, Kentucky farm. As he strolled about the property that day, visiting such residents as turf champion Sunshine Forever and French Group 1–winning Creator, it occurred to him that this was a story that was begging to be told. And so he told it.

Celebrating Old Friends: Stories from Kentucky's Thoroughbred Retirement Farm has been two years in the making. Rick, a sports journalist and skilled photographer, combined those talents in pulling this book together through dozens of personal interviews, anecdote-filled first-person accounts and hours of in-depth statistical research. It evolved into a labor of love, which is what Old Friends is really all about as well. Interspecies affection is the norm at this very special place, where volunteers and employees form unbreakable bonds with the horses they care for and come to know so well: John Bradley and Mixed Pleasure, Angela Black and Sea Native, Barbara Fossum and Hidden Lake, Don Veronneau and Leave Seattle…everybody and Little Silver Charm. Stories in this volume reveal what these generous animals can mean to us and the many gifts they bring.

Much has happened at Old Friends since Rick's first book was published in 2014. This work brings us up to date with the 2015 opening of a satellite facility at Kentucky Downs; the prominent (and not-so-prominent) new equine arrivals—including a trio of dual classic winners; and the loss of several cherished members of the Old Friends family, such as champion Hidden Lake, unconquerable Wallenda, courageous Delay of Game and, of course, the unexpected passing of Kentucky Derby and Preakness Stakes winner Charismatic.

Rick's book takes us to this remarkable acreage where so many Thoroughbreds have come to live the good life as the horses they were born to be—and, ultimately, to die in peace. Through these pages, we walk alongside Michael Blowen, talk with manager Tim Wilson and learn from Dr. Bryan Waldridge. We read about the careers of these equine athletes, from Hall of Fame champion Silver Charm to loveable 0-for-100 loser Zippy Chippy, and we fondly remember those that have crossed the Rainbow Bridge. Along the way, we travel the twisting, serendipitous roads of life that brought each of them to Old Friends.

MARY SIMON,
three-time Eclipse award winner

ACKNOWLEDGEMENTS

*Y*ou know the saying, "It takes a village." Well, to write a book, that's what it takes to complete the finished product.

A big thank-you goes to all the great photographers who allowed me to use their photos in this book: Laura Battles, who came through when I couldn't get up to the farm to get some of the photos, especially Charismatic, who died way too soon; Connie Bush, who takes beautiful photos of Old Friends at Cabin Creek; and Adam Coglianese, the great NYRA photographer who allowed me to use his photo of the finish of the 1997 Belmont Stakes between Silver Charm and Touch Gold. In addition, thanks to Carole Oates, Joyce Patci and Tim Wilson, who also work magic with their cameras.

Another big thank-you goes to the people who shared their stories about the horses at Old Friends, starting with best-selling author Laura Hillenbrand, who did an e-mail interview about Genuine Reward, as well as allowing me to use her beautiful essay about Gulch that she shared on her Facebook page; Hall of Fame jockey Chris McCarron, who shared his descriptions of his ride on Touch Gold winning the Belmont Stakes over Silver Charm, as well as his ride on Alphabet Soup winning the 1996 Breeders' Cup Classic; Don Veronneau, for his heartwarming story about his beloved Leave Seattle; Angela Black, for her beautiful story about "Rhett," her nickname for her horse Sea Native; and Vivian Morrison, for her story on "her boy," Mikethespike.

I also want to send a special thank-you to Ercel Ellis and his wife, Jackie, for inviting me out to their beautiful farm in Bourbon County for an interview.

Acknowledgements

Thanks also go to all the folks at Old Friends who put up with me pestering them for interviews and questions, including Tim Wilson, Carole Oates, Tammy and James Crump, Sylvia Stiller, Cindy Grisolia, Beth Tashery Shannon, Barbara Fossum and Dr. Bryan Waldridge.

A special thank-you goes to Mary Simon for writing a beautiful foreword for this book.

I'd like to thank The History Press for allowing me to write a second book about Old Friends. It is something it does not always allow, but with the growth of the farm and all of the big-name horses that arrived, it made an exception. Also thank you to my commissioning editor, Candice Lawrence, who kept me focused and on track throughout the project, and to my senior editor, Ryan Finn, for his edits an ideas on improving the book during the review process, as well as to senior editor Hilary Parrish, for the last-minute corrections she found during a final proofread of the book.

Another thank-you goes to my former co-worker Bob Vlach for taking the time to do one of his excellent edits. A big thank-you also to Diane White, Michael's "better half," for taking the time to sit down with Little Silver Charm while he dictated his "update" for the book.

The biggest thanks goes to my friend Michael Blowen, who created Old Friends so that Thoroughbreds, especially stallions, have a beautiful place to enjoy a peaceful and dignified retirement while also giving horse racing fans, like myself, a place to come visit some of the sport's great racehorses.

INTRODUCTION

*E*xcept for music, movies and horses, I'm not much for looking backward. But Rick Capone's new work about Old Friends allows me the pleasure of floating back through the many years of horses and humans who have come together to make Old Friends the special place it has become.

What our donors, employees and volunteers have created is astounding. And I believe that most of them would say, as I do, that the horses have done more for them than we've done for the horses.

In a larger sense, as the concise images Rick has created verify, we've proven that these Thoroughbreds have great value beyond their racing and breeding years. Along with trainers such as Bob Baffert and D. Wayne Lukas and jockeys Chris McCarron, Kent Desormeaux, Victor Espinoza, Joe Steiner and many others, visitors come from all over the world to feed Silver Charm a carrot and relive their lives in racing through his. They don't come to bet or race, but rather to show their respect for these extraordinary athletes.

Over the years, we've been honored with a special Eclipse award, the Lavin Cup from the American Association of Equine Practitioners, the Joe Palmer Award from the National Turf Writers, the Kentucky Thoroughbred Owners and Breeders Achievement Award, the Sam McCracken Award from the New England Turf Writers and others. These acknowledgements are a tribute to all who have ever stepped foot on our farms in Georgetown, Old Friends at Cabin Creek or Old Friends at Kentucky Downs. It's for the people who have supported us through the tough times and the great times with their hard work and dedication.

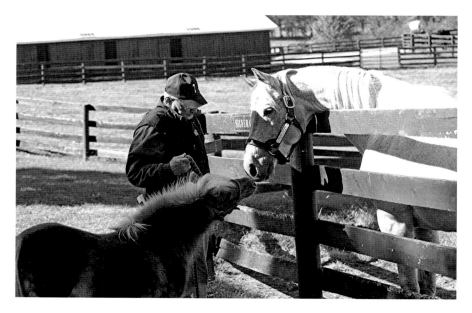

Michael introduces his two favorite horses to each other, Little Silver Charm and Silver Charm. *Courtesy of author.*

Old Friends is a tribute to a vague, foggy idea that became a reality because of all the people who helped fill the massive gaps in the original conception. During the few times over the past fourteen years when I thought we might fail, it was already too late to disappoint our fans and, most importantly, the horses.

At seventy, it's still not time to reflect; I'd rather cut up some carrots, feed Little Silver Charm and try to get War Emblem to like me just a bit. It's a life that makes me eternally grateful to be blessed with such great new and old friends of the two-footed and four-footed variety. We will continue to do what's right by the horse. It's worked so far, and I'm confident it'll continue working and growing into the future.

Through Rick's hard work and diligent research, visitors are able to take a little bit of Old Friends home with them. I hope they enjoy reading and re-reading the stories as much as I did. And it all begins with the story of my all-time favorite horse, Silver Charm.

MICHAEL BLOWEN,
Founder and President, Old Friends

Chapter I

SILVER CHARM

December 1, 2014

On a cold, drizzly winter's day, a Sallee Horse van turned off Paynes Depot Road and onto a side road that leads to Old Friends, the Thoroughbred retirement farm in Georgetown, Kentucky. Driving slowly to protect its precious cargo, the van turned onto Byars Way, the main road at Old Friends named after Dr. Doug Byars, who was the farm's original equine veterinarian.

At the top of the hill, a crowd of nearly one hundred people was standing in the rain and becoming more and more excited as the van got closer. Nobody cared that they were wet and cold.

The van reached the top of the hill, then drove around the big barn and came to a stop in front of the smaller barn. The driver got out and opened the side door of the van. Inside, Sandy Hatfield, the stallion manager at Three Chimneys Farm, could be seen pulling some partitions away and putting a lead onto Old Friends' newest retiree. Meanwhile, the driver secured a ramp to the van so the horse could walk comfortably down to the ground.

At the bottom of the ramp stood Michael Blowen, founder and president of Old Friends, who was just as excited as everyone else awaiting the appearance of the horse.

Soon, Sandy led the horse down the ramp and onto the green grass of Old Friends. The beautiful gray stallion stood tall and proud, his head held high as he looked over his new surroundings and at all the people who stood

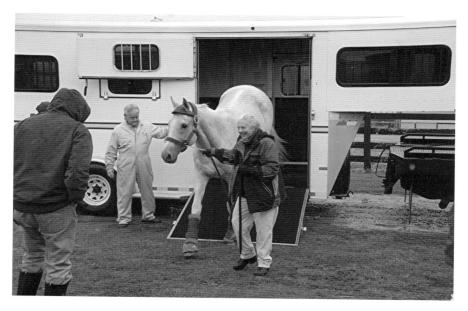

Silver Charm, 1997 Kentucky Derby and Preakness winner, arrives at Old Friends and is led off the van by Three Chimneys' Sandy Hatfield while Michael looks on. *Courtesy of author.*

before him in complete awe of his beauty. Michael gave Sandy a hug, and the two turned together and looked at the new arrival.

Silver Charm, the 1997 Kentucky Derby and Preakness Stakes winner, had arrived safely at Old Friends to enjoy his retirement. Michael's dream had finally come true. Not only was his all-time favorite horse now at Old Friends, but the farm also finally had its first Kentucky Derby winner.

"Everybody always asks people what was the greatest day of your life," said Michael. "I used to say the day I got married. Then my son was born, so it was the day my son was born. Then my grandson was born, so it was the day my grandson was born. Well, now my family barely fills out the superfecta because the greatest day of my life was December 1, 2014, on a really cold day, when Sandy Hatfield walked Silver Charm off a Sallee Van and led him into the paddock here at Old Friends."[1]

Silver Charm, who is by Silver Buck-Bonnie's Poker, by Poker, was foaled February 22, 1994, in Florida. His breeder was Mary Lou Wootton.

Coincidentally, Silver Charm's dam, Bonnie's Poker, was also a retiree at Old Friends. She died on August 5, 2010.

Owned by Bob and Beverly Lewis and trained by Bob Baffert, who in 2015 trained American Pharoah to the Triple Crown, Silver Charm raced three times as a two-year-old in 1996, won two times, finished second once and earned $177,750.

Then, in his three-year-old season in 1997, he won three races, finished second four times and earned $1,638,750 in seven starts. His biggest wins, the ones that put him into the history books, were the Kentucky Derby (G1) and Preakness Stakes (G1).

Many believed that Silver Charm would win the Belmont Stakes to finally capture the Triple Crown for the first time since Affirmed in 1978. However, that did not happen. With Hall of Fame jockey Gary Stevens riding, Silver Charm was leading down the stretch and appeared to have the Belmont win locked up. But on the outside, where he couldn't see, Hall of Fame jockey Chris McCarron was coming on strong aboard Touch Gold and passed Silver Charm at the wire before he could react.

While Silver Charm lost his bid at the Triple Crown, his success in the Kentucky Derby and Preakness Stakes earned him the 1997 Eclipse award as Champion 3-Year-Old Male.

Silver Charm raced two more seasons and had some great wins. The biggest came as a four-year-old, when he won the 1998 Dubai World Cup. Upon retirement, he had eleven wins, seven seconds, two thirds and $4,444,369 in earnings in twenty-two career starts.[2]

Silver Charm began his stud career at Three Chimneys Farm near Midway, Kentucky. He stood there until 2005 and then went to the Shizunai Stallion Station in Japan to finish out his stud career.

One day in late 2014, Michael got the call he had long hoped to get:

> *Silver Charm is my favorite horse of all time. When he won the Derby and Preakness in 1997, I was still working for Carlos [Figueroa] with the $3,500 claiming horses. Then when he was going into the Belmont Stakes—I think the year before the attendance for the Belmont was like 36,000 to 37,000, and when he ran in the Belmont, I think it was up to 90,000 and 100,000. He was like the salvation of racing in the late 1990s. He brought a lot of new people to the sport, and he really got my enthusiasm up.*

Then he went to Dubai and won the Dubai World Cup. He just did everything, and I adored him. That's why I named my little horse Little Silver Charm eighteen years ago—because Silver Charm is my favorite horse.

Years go by, and we build up this really good relationship with the Japanese Bloodhorse Breeders Association (JBBA) and with Shizunai Stallion Station, and we start keeping our options open for when these breeding horses in Japan retire so they can come to Old Friends. We already had brought home five horses from Japan—Sunshine Forever, Creator, Fraise, Ogygian and Wallenda—at that point, and I'd always had my eye on Silver Charm.

Well, I think it was late October or early November [2014], I got a call from Sandy Hatfield, who's the stallion manager at Three Chimneys, where Silver Charm stood during the American phase of his stallion career. She said to me, "How would you like an old, gray stallion at your farm?"

I knew exactly who she meant, and I went absolutely out of my mind. But before I could go completely crazy, she added, "You can't tell anybody."[3]

Now, Michael, as he readily admits, has a hard time keeping secrets, but he knew he had to keep this one because he didn't want to possibly mess up the deal. He continued the story:

So, I got on one of the golf carts and drove to the back of the farm, and I ran around screaming like an eight-year-old. I mean if anybody had seen me or heard me I would have been locked up. I was just so excited.

Then, on top of that, I found out that Jeff and Marge Lewis, the son and daughter-in-law of Bob and Beverly Lewis [the owners of Silver Charm], had put money away to pay for everything. I think it was right around $70,000. And not only did they pay for everything, they had a stipend built in so that they were going to send $10,000 a year for his care at Old Friends.

So, here's a situation where I would have had to raise the $70,000 [to bring the horse home], but…we got paid and everything worked out really well to bring Silver Charm home. It's a great example of everybody working together from Silver Charm's past, and the gratitude for all the horse did for the Lewis family, and his future here at Old Friends.[4]

———

Of course, getting Silver Charm to Old Friends was a bit of a process. According to an article by Claire Novak on BloodHorse.com on December 2, 2014, "After spending three weeks in quarantine in Japan, Silver Charm left that country the last week of November on an 18-hour flight with a layover in Anchorage, Alaska, and from there traveled to Chicago, where he was quarantined four days at Arlington International Racecourse....Finally, after shipping eight additional hours by van from Illinois to Kentucky, he arrived at the farm that will be his forever home 'just as cool as a cucumber,'" said Michael in the article.[5]

————

One of the heartwarming stories about Silver Charm's arrival is what Michael clutched in his hand while waiting for Silver Charm to arrive:

> *I was talking to Sandy Hatfield one time over at Three Chimneys. I went over to see Seattle Slew, I think. But I was over there, and I was going crazy telling her that Silver Charm was my favorite horse of all time. Then she went to get something, and she came back and handed me the last halter he had worn before he left for Japan.*
>
> *She said to me, "You should auction this off and make money." But I saved it, and I saved it, and I saved it. And every time, no matter how bad things got [financially]—and we had some nose finishes, let me put it that way—I could not surrender that halter. I'd auction off any possession I had, but I couldn't give away that halter.*
>
> *So, when Silver Charm got here and I got to put it on him, it was just unbelievable....That's what happened...for me and Silver Charm.*[6]

————

Since his arrival at Old Friends, Silver Charm has had many visitors, including Gary Stevens, who rode Silver Charm to his Kentucky Derby and Preakness wins. A few other visits have really been memorable for Michael, too. The first one was a fun one:

> *One of the things I tell visitors on tours is that I know a lot of people who go to sales and look at breeding and conformation. But, to me, I wouldn't worry as much about those things.*

The two Derby winners we have here, Silver Charm and War Emblem, neither of them have very good breeding. I mean, Silver Buck never produced that much, and certainly Our Emblem didn't either besides War Emblem. And if you look at Silver Charm's conformation, it's not that good either.

So, one day a woman came on a tour, and we talked about conformation and Silver Charm's breeding, and I said, "I wouldn't worry as much about conformation and breeding as intelligence and will and heart. That's a lot harder to measure than conformation and breeding."

She said, "Yeah, he's turned out a little in the front."

"Wow!" I said, "You're pretty smart. How did you know that?"

She said, "Ask my husband." By then I knew that something was going on.

She said, "Yeah, I was the underbidder for Silver Charm. I got up to $80,000, and my husband—him [pointing to her husband]…I turned to my husband and he said, 'I wouldn't go any higher. He's turned out in the front.'"

By now we're all looking at Silver Charm's feet, and everybody on the tour is going, "Wow!"

I turned around to the guy, and I asked [jokingly], "How come you haven't either gotten divorced or committed suicide? Because how could you stand to hear this every day?"

He said, "I know. It's pretty bad."

Everyone laughed and had their picture taken with Silver Charm. They all seemed to have a great time.[7]

The second memorable visit for Silver Charm was by Hall of Fame trainer Bob Baffert; his wife, Jill; and their son, Bode, the week before Bob's horse, American Pharoah, won the Kentucky Derby.

According to an article by Steve Haskin in the May 9, 2015 edition of *Blood-Horse* magazine, Bob's visit to Old Friends to see Silver Charm, the horse he had trained during his racing career, was almost calming in a way for him. Haskin wrote:

Baffert had been to Churchill Downs with the Derby favorite before during the past 12 years, but this year was different. This year he had an old friend to help relieve any anxieties he might be experiencing and to remind him of a special time in his life when he transcended the sport and his profession to become a national celebrity. That special friend, whose toughness and courage first brought Baffert into the hallowed winner's circle of the Kentucky Derby in 1997, was Silver Charm, who had recently arrived at

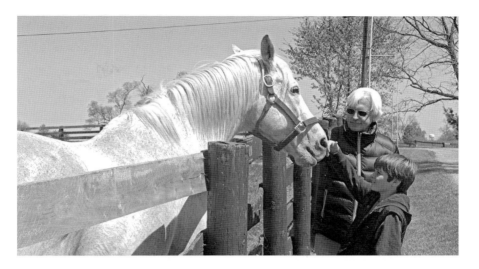

Silver Charm is visited by his former trainer, Bob Baffert, and his son, Bode, the week before the 2015 Kentucky Derby. *Courtesy of Tim Wilson.*

the Old Friends retirement facility in Georgetown, Ky., after spending nearly a decade in Japan. Several days before the Derby, Baffert, Jill, and Bode made the drive east on I-64 to visit Silver Charm, who is now as white as his trainer's hair.

It proved to be a cathartic experience as Baffert was reunited with the horse who had made his career and endeared him to a nation. A trip back to the past can bring the present into focus and make one realize how fortunate he was, and is, today. It was time for Baffert to introduce his past, and who he is, to his son in the living form of Silver Charm, who before that was just a name and a dashing figure seen on video.

"Bob was overwhelmed seeing him," Jill said. "This was the horse who started it all, and I think that's why Bob got so emotional. He's like your first love. He holds that special place in Bob's heart."

Baffert added, "Oh, my God, he got me. We saw him from far away and all of a sudden when [Old Friends founder] Michael Blowen called him he came trotting to the fence. He's still the same tough horse. I wanted to cry. He made me so emotional."[8]

Now, here's another of those special Old Friends asides to tie this story together. Some people at the farm, including Michael, believe in something called "Old Friends Karma." For example, when you are at the track and

can't make a decision on a horse to pick in a race, if the horse has an Old Friends retiree in its pedigree, bet that horse. A lot of times that horse comes home in the money.

That brings us back to Bob and his family's visit to Old Friends just a few days before American Pharaoh's Kentucky Derby win, which was followed by his Preakness Stakes win and then his Belmont win, which made him the first Triple Crown winner in thirty-eight years. Add in his Breeders' Cup Classic victory at Keeneland in November that year to complete the Grand Slam of horse racing—who knows, it just might have been "Old Friends Karma" working once again!

———

It's another beautiful morning in central Kentucky. Quietly, the back door to the main house slides open at Old Friends, and out steps Michael wearing jeans, a blue Old Friends shirt and a tan Old Friends hat with Silver Charm emblazoned on it.

Carrying a bucket of carrots, he's on his way to visit Silver Charm in the paddock behind the house and then over to see Little Silver Charm. When he arrives at the fence, Silver Charm is grazing at the far end of the paddock. "Silver Charm. Silver Charm," Michael calls. The big gray stallion lifts his head, looks over and then goes back to grazing.

Then Michael calls, "Who's the greatest horse in the history of the universe?" This time, Silver Charm looks up and begins to walk over to Michael. Within a few steps, he breaks into a trot and then a cantor. It is one of those beautiful sights to behold, and it takes your breath away.

Before you know it, the big horse arrives at the fence to greet Michael and get his morning treats. "He is everything you could possibly imagine," said Michael. "He's really lived up to my considerably high expectations. He's fulfilled them enormously with his manner, his intelligence; he knows who he is. He's got a tremendous amount of class. There's just not a day that goes by that I'm not really grateful that he ended up in my yard.…He's majestic. He's everything imaginable because he is so perfect."[9]

Chapter 2

TOUCH GOLD

*T*here are many unique things about Old Friends. One of them is that the farm is now home to two Triple Crown–winning pairs—Silver Charm and Touch Gold and War Emblem and Sarava.

Touch Gold, the horse that denied Silver Charm the Triple Crown in 1997, now lives in the paddock across from Silver Charm. Some days, you might even catch them just staring over their fences at each other—no doubt discussing who is the faster horse. Just imagine how that conversation might go.

———

Touch Gold was foaled on May 26, 1994, in Kentucky by Holtsinger Inc., Hill 'n' Dale Farm and Star Stable. He is by Deputy Minister (Can.)-Passing Mood (Can.), by Buckpasser.

The beautiful dark brown Thoroughbred had a good racing career, with his best year coming as a three-year-old, when he won the Belmont Stakes (G1), Haskell Invitational Handicap (G1) and the Lexington Stakes (G2).

When he retired at the end of his four-year-old season, he had six wins, three seconds, one third and $1,679,907 in earnings. His career was capped in 2011, when he was inducted into the Canadian Hall of Fame.[10]

———

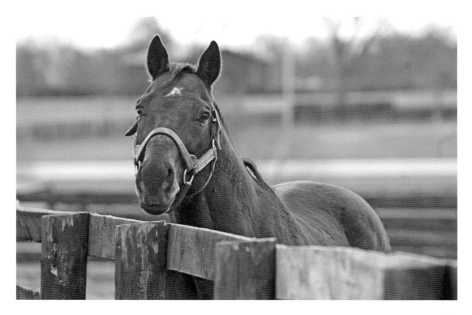

Touch Gold, the horse that defeated Silver Charm in the 1997 Belmont Stakes, now lives across the fence from his former rival. *Courtesy of author.*

As noted, Touch Gold's biggest career win was the Belmont Stakes, and according to Michael Blowen, one of the fun things to do is listen to Hall of Fame jockey Chris McCarron talk about his ride on Touch Gold in that race.

Chris was the original rider on Silver Charm, but he gave up Silver Charm before the Kentucky Derby because he was loyal to Ron McAnally, who gave him many good mounts, most notably John Henry.

When asked about the Belmont Stakes and Touch Gold, Chris was more than happy to tell the story:

> *I rode Silver Charm in his first two starts as a three-year-old. I rode him in the San Vicente [Stakes] going seven-eighths [of a mile], and he [finished second]. Then, about three weeks later, I rode him in the San Felipe [Stakes] going a mile-and-a-sixteenth, and we won.*
>
> *Then I had the opportunity to ride him in the 1997 Santa Anita Derby, but I went with my heart instead of my head and rode a horse for Ron McAnally called Hello. I made that decision based on the fact that I wanted to show my allegiance to Ron because he was one of my first really big supporters when I moved out to the West Coast in 1978. He put me on*

a lot of winners. I just had started riding for [Bob] Baffert at the time. He rode me sparingly. So, I just wanted to ride for my number one guy.

Then, the way I got the mount on Touch Gold....Gary Stevens rode him in the Lexington Stakes about two weeks before the Derby. Obviously, he was committed to ride Silver Charm. He picked up the mount on Silver Charm in the Santa Anita Derby and finished second to Free House.

So, Gary was committed to Silver Charm, and that left Touch Gold open. I've ridden a lot of horses for [trainer] David Hofmans, so he was kind enough to offer me the mount. He [Touch Gold] went wire-to-wire in the Lexington and won very impressively. And if he didn't stumble coming out of the gate, he would have gone wire-to-wire in the Preakness.

Then, in the Belmont, I had it in my head before the race began, as far as strategy goes, that if I had the opportunity to get to Silver Charm, if I wasn't going to be in front of him, if I was going to be stalking or whatever, I was going to get way out away from him because he's a very dogged fighter. Anytime a horse ran up alongside of him, he almost never would let the horse go by. He did a few times, but most of the time, he would out-game his competitor.

So, I was in front going into the first turn, and he [Touch Gold] was really pulling me out of the saddle. Then, when he got about a length in front, he threw his ears up and relaxed really well, and he slowed the pace down; he let me slow the pace down.

Then, as we went around the turn, Gary Stevens on Silver Charm and Kent Desormeaux on Free House knew the pace was slowing down and they didn't want it to slow down, so they both let their horses run on a little bit. [Now], everybody thinks that I took Touch Gold back at that point. I didn't really take him back—I just didn't allow him to quicken. So, it looks like I'm taking him back off those other horses, but they passed me and I just didn't let Touch Gold go.

Then I sat there and waited 'til the head of the stretch, and here I was in the position I was hoping for. I got way out in the middle of the racetrack away from Silver Charm, and we were able to run him down.[11]

So, with Silver Charm on the inside and Free House in the middle, Chris and Touch Gold came along on the outside and slipped by Silver Charm near the wire before he could react. "Yep, that's pretty much how it happened," said Chris with a smile.

———

Upon retirement, Touch Gold stood at McMahon Thoroughbreds of Saratoga, New York, before going to Adena Springs, where he completed his stud career. That's when a chance meeting brought Touch Gold to Old Friends.

According to Michael, Jack Jeziorski, who works for Frank Stronach in the Stronach Group, came to Old Friends one day, and the two talked. During their conversation, Michael mentioned that Old Friends would love to retire some of the Adena Springs stallions when the time comes. Jeziorski said he'd mention it to Stronach.

Sometime later, Michael became friends with Stacie Clark Rogers and her husband, Mike Rogers. Mike is one of the people who heads up the Stronach Group, and Stacie now runs the Thoroughbred Aftercare Alliance. So they knew that Old Friends was a good place, and Michael figured they would start talking to Frank Stronach about it.

Soon, some people from Adena Springs came to the farm to look it over. Then, a few weeks later, Michael got a call, and they said, "We're going to retire Touch Gold and Alphabet Soup. Do you want them?"[12]

According to Michael, this whole process took about a year and a half, but it was worth the wait, as "not only did they give them to us for free… and not only did they come here in fabulous shape and great condition with marvelous personalities, but every year, the Stronach Group gives us a lot of money to take care of them. That was just great."[13]

———

Like Silver Charm, Touch Gold is very intelligent and seems to understand being at Old Friends. During the day, he usually stands down in the lower part of his paddock. Then, when a tour appears and he hears his name called, well, he knows it's showtime!

He'll look up and then begin to walk across his paddock. Soon, his walk turns into a trot and then a run. When he arrives at the fence, everyone "ooohs" and "ahhs." He looks at the visitors and poses for photos as the tour guide tells his story and gives him some carrots, and everyone has a fun time.[14]

Chapter 3

WAR EMBLEM

*T*he first day War Emblem was let out into his double-fenced paddock specifically built for him at Old Friends, it was one of those beautiful Kentucky days. The show the almost black stallion put on was one to remember.

Michael Blowen recalled what happened after they let him off his lead line: "He looked around his paddock, then began to run around the fence. After doing that for a while, he ran into the middle of the paddock, reared up on his hind legs and pawed the sky while loudly neighing to all that could hear as if to say, 'I am here!' It was just amazing to see."[15]

War Emblem was foaled in Kentucky by Charles Nuckols Jr. and Sons. Both Charles Nuckols III, who now owns Nuckols Farm, and Alfred Nuckols, who now owns Hurstland Farm, both in Midway, Kentucky, are big supporters of Old Friends.

War Emblem, who is by Our Emblem-Sweetest Lady, by Lord at War (Arg.), was foaled on February 20, 1999.

His biggest wins came as a three-year-old when he won the Kentucky Derby and Preakness Stakes. He also won the Haskell Invitational Handicap and Illinois Derby that year. Unfortunately, War Emblem lost the Belmont Stakes and the Triple Crown to Sarava, the longest shot to ever win the Belmont Stakes.

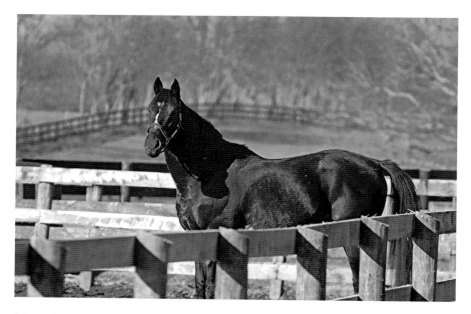

War Emblem, winner of the 2002 Kentucky Derby and Preakness, has settled into retirement nicely. *Courtesy of author.*

Now, many people say that War Emblem lost the Belmont to Sarava and make it sound like Sarava beat him in a close finish. But that is not the case. War Emblem lost the Belmont Stakes at the starting gate when he almost fell at the break but was saved by his jockey, Victor Espinoza. However, by the time Espinoza could straighten out his horse, the race was over for him and he finished eighth.

When he retired at the end of his three-year-old campaign, War Emblem had seven wins in thirteen starts and $3,491,000 in career earnings. For his efforts, he earned the Eclipse award as Champion 3-Year-Old Colt.[16]

War Emblem then went to Shadai Farm in Japan in 2003 to begin his stud career. While he really was never interested in "the ladies," he did manage to sire some good horses—122 foals in all, including Grade 1 winners Black Emblem and Robe Tissage.[17]

In 2015, he was pensioned and eventually ended up being sent to Old Friends, thanks to a lot of work by a lot of people, according to Michael. It began when Michael got an e-mail from Emmanuel de Seroux, who's been so essential to getting these horses back to America and Old Friends from Japan. In the e-mail, Emmanuel told Michael that War Emblem was going to be pensioned and asked if he would like to get him to Old Friends.

Michael said yes, as War Emblem is another horse he'd been trying to bring home for a long time. However, he would have to raise the money.

Now, this was around the time that American Pharoah won the Triple Crown and was getting ready to run in the Breeders' Cup Classic at Keeneland. So, Michael and Old Friends came up with a great marketing plan to get War Emblem home.

"Since American Pharoah was riding a crest of his great popularity with Bob Baffert and jockey Victor Espinoza, I talked to Jill Baffert about the idea of getting Bob and Victor to sign pictures of War Emblem and then we could auction them off," said Michael. "Eclipse award–winning photographer Barbara Livingston was kind enough to donate her photograph of War Emblem's Derby win to us. We made three hundred of them and sold them for $202 in honor of War Emblem's 2002 Kentucky Derby win. We raised almost all the money we needed to bring him back with those photograph sales."[18]

War Emblem arrived in the United States in the fall of 2015 and was put in quarantine at Rood & Riddle Equine Hospital to breed to two test mares to be cleared. But it did not happen. Just like his stud career, he was not interested in the mares. However, while he was there, Michael visited him every day with a bucket full of carrots, and as seems to happen with all horses, War Emblem, who is supposed to be "really mean," turned to putty with Michael.

After a month with no test breeding taking place, it was decided to send War Emblem to Old Friends, where, in a more comfortable environment, he might do the test breeding. Prior to War Emblem's arrival at the farm, a double fence was built around one of the paddocks so no one would be able to interact with him for safety and quarantine reasons.

Well, War Emblem arrived and settled in but still wanted nothing to do with test breeding. So, a decision had to be made—geld him or send him back to Japan. It was a tough decision, but everyone really wanted War Emblem to stay at Old Friends, so the decision was made to geld him.

In a February 24, 2016 Old Friends newsletter, an explanation was given for the decision:

> When a stallion is imported into the United States from any foreign country, the United States Department of Agriculture (USDA) has various "import" regulations, including a requirement that says the stallion must do a "test breeding." The reason behind this is to determine if the animal is infected with, or a carrier of, the very serious disease known as Contagious Equine Metritis or CEM.

> *CEM is a highly contagious bacteria—which has more or less been eradicated in the U.S.—and can be spread during live breeding, artificial insemination, or through contact with contaminated objects.*
>
> *CEM-positive horses that show no signs of illness (called "carriers") can cause outbreaks at breeding facilities. It is highly contagious among horses and can be difficult to detect and control.*
>
> *While it is clear that War Emblem, as a retired resident of Old Friends, would never be called upon to breed, the USDA is still obligated to consider that an intact stallion carrying CEM could get loose and inadvertently breed a mare or dispel the disease via human interaction with infected semen.*
>
> *If the disease should again became widespread in the United States, the horse industry could suffer considerable economic losses.[19]*

After deliberation, it was determined they should castrate him. All necessary precautions were taken, and the surgery was a success. War Emblem responded well and fully recovered. He now enjoys the peaceful life in retirement that he deserves.

For almost his entire career, War Emblem has been known to be difficult. He was often said to be a mean horse. "War Emblem is extremely intelligent and has tremendous willpower," said Michael. "I'm not sure he likes people. I don't think it was because he was abused or neglected or any of that, because he wasn't at all. In fact, just the opposite. People were trying to be nice to him all the time and he treated them like dirt."[20]

However, following his gelding, he's slowly becoming a little nicer, as was seen the morning of the new barn opening at Old Friends before visitors started to arrive. On that morning, Tim Wilson, Old Friends' farm manager, walked into War Emblem's paddock and placed his grooming kit next to the run-in shed. Meanwhile, down at the other end of the paddock, War Emblem saw Tim and watched him with curiosity.

Tim cautiously approached War Emblem. As he did, War Emblem continued to watch him but did not run away. Carefully clipping a lead onto his halter, Tim turned and began walking back to the run-in shed as War Emblem quietly followed along.

At the run-in shed, Tim held the lead line with one hand and began to groom War Emblem with the other. The horse would occasionally try and pull the lead away, but for the most part, he just relaxed and enjoyed the

brushing. At one point, as if he were a young colt again, War Emblem pulled the fly-spray bottle out of the kit and started shaking his head with it in his mouth as if to say, "Hey, there are flies around here. Would you please spray me with this stuff?" Soon, Tim was done and unclipped the lead line, and War Emblem casually strolled over to the fence to visit the people who stood there admiring him.

War Emblem is a beautiful horse and has become a fan favorite—possibly because while his official color is called brown/dark brown, he is as close to the fictional "Black Beauty" as it gets.

Chapter 4

SARAVA

*W*hen it comes to carrots, there are a few horses at Old Friends that have figured out how to be double dippers. One of those is Sarava, the 2002 Belmont Stakes winner. But before telling the story of his double-carrot dipping, here's the story about what made him famous.

―――――

Sarava was the first Classic winner to arrive at Old Friends. He preceded Silver Charm, War Emblem and Touch Gold. Thanks to co-owners Gary Drake of Louisville and Paul and Susan Roy of Great Britain, Sarava arrived at Old Friends on Saturday, September 29, 2012.

"Sarava is the first Classic winner to retire at Old Friends," said Michael Blowen "We are thrilled that Gary [Drake] would trust us with his great stallion and grateful for the generous endowment from him and the Roys. I also want to thank former Midway [Kentucky] mayor and bloodstock agent Tom Bozarth for his assistance. I know Sarava's fans will love to visit him."[21]

Now, two things should be known about Sarava's Belmont Stakes win in 2002. First, while Sarava did win the race, War Emblem's chances of winning the Belmont, and thus the Triple Crown, were over at the start. When the gates opened, War Emblem stumbled badly, but thanks to the efforts of his jockey, Victor Espinoza, he straightened the horse out and finished eighth without injury.[22]

Second, Sarava won only two stakes races in his career: the Sir Barton Stakes on May 18, 2002, at Pimlico and the Belmont Stakes (G1) on June 8,

Sarava, winner of the 2002 Belmont Stakes, enjoys a run around his paddock. *Courtesy of author.*

2002, at Belmont Park. He did not win again after the Belmont—but what a glorious win it was that day.

In the race, he broke from post at 70-to-1 odds under jockey Edgar Prado, and while War Emblem was trying to get his balance, Sarava settled into fifth place behind the early pace, which was being set up front by Medaglia d'Oro, who was ridden by Kent Desermouex.

Down the backstretch, Sarava stayed in fifth, but as he entered the far turn, he began to move to the inside. Meanwhile, Medaglia d'Oro continued his run at the front. As the horses rounded the turn and reached the quarter pole, Sarava ran between two horses, charged toward the leader (Medaglia d'Oro) and then battled on the outside of him in the upper stretch. He was then urged to the front nearing the furlong marker, turned back a late charge by Medaglia d'Oro and, under steady right-hand urging, crossed the finish line the winner by a half-length. Medaglia d'Oro finished second and Sunday Break (Jpn.) finished third.[23]

Sarava ran the 1-1/2-mile race in 2:29.71 and became the longest shot ever to win the Belmont Stakes in history. He paid $142.50 to win, $50.00 to place and $22.40 to show.

By Wild Again-Rhythm of Life, by Deputy Minister, Sarava was foaled on March 2, 1999, in Kentucky. He was trained by Ken McPeek.

Sarava ran eight more times in his career, all of them in his four-year-old season, but he never won again. He retired with three wins, three seconds, three thirds and $773,832 in earnings in seventeen career starts.[24]

He stood at Cloverleaf Farms in Florida in 2005 and then in Kentucky in 2007 and back to Florida from 2008 to 2012. The final place he stood was Bridlewood Farm near Ocala, Florida, from 2010 to 2012. Following his stud career, thanks to his owners, thirteen-year-old (at the time) Sarava was donated to Old Friends.

───────

Today, Sarava has his own paddock located directly behind the Old Friends office. It's the first paddock visitors pass on a tour, which brings us back to the story of how he learned to double-dip carrots. While other horses also do some double-dipping depending on where their paddocks are located, Sarava really seems to enjoy it. You see, when a tour begins at Old Friends, the first paddock they reach is Sarava's, where he is either already waiting to greet them or, as soon as he sees them, he goes over to the fence. Then, as the tour guide tells his story and feeds him some carrots, Sarava poses for photos.

Now, on some days, there are multiple tours, and on those days, watch Sarava closely. While he stands on one side of his paddock getting carrots and getting his photo taken, he is also carefully watching the tour on the other side of the paddock. Then, as soon as the first tour group begins to walk away, Sarava will quickly dash to the other tour, where he'll stand by the fence, and while the tour guide tells his story, he'll get some more carrots—smart horse.

Chapter 5

CHARISMATIC

On Saturday, June 5, 1999, the stands were full at Belmont Park as horse racing fans had come to see if Charismatic would make history. Already that spring, the former claimer had won the Kentucky Derby (G1) and Preakness Stakes (G1) and now seemed poised to win the Belmont Stakes (G1) to become the first horse to win the Triple Crown since Affirmed in 1978.

As the horses were loaded into the starting gate, the excitement and anticipation grew. Soon, the bell rang, the gates clanged open and the race was on.

The horses ran around the track. Then, as they rounded the final turn and were heading down the stretch, Charismatic, who was ridden by jockey Chris Antley, was battling for the lead. But suddenly, he slowed and was passed by Lemon Drop Kid and finished third.

A little past the finish line, Antley pulled him up. Everyone was stunned as they watched Antley jump from the saddle and look at his horse, who was now limping. Then, in a scene that is etched in the memory of everyone who watched that day, Antley lifted Charismatic's leg up to try and prevent further damage.

Many people did not even realize that Lemon Drop Kid won the race that day. But everyone remembers what Antley did that day for Charismatic. As Jay Hovdey wrote in the *Daily Racing Form*, "The Triple Crown was lost, but Charismatic was saved."[25]

Charismatic never raced again, but he lived to stand at stud at Lane's End Farm in Versailles, Kentucky; in 2002, he was sent to Japan.

Sadly, Chris Antley, the man who saved Charismatic, died on December 2, 2000. He was thirty-four and later inducted into the National Racing Hall of Fame.

––––––––––

Charismatic was foaled in Kentucky on March 13, 1996. He began his racing career as a two-year-old and raced seven times but only won one time. Then, as a three-year-old, he began to blossom under the tutelage of trainer D. Wayne Lukas. But it did not come easy.

He opened 1999 by running in claiming races at Santa Anita. But by April, "he had surged to the top of the 3-year-old racing world by capturing the Coolmore Lexington Stakes (G2) at Keeneland. He then went on to victories in the Kentucky Derby and Preakness Stakes at long odds, and suddenly found himself at the threshold of becoming the world's 12th Triple Crown winner, which did not happen."[26]

Charismatic retired with five wins, two seconds, four thirds and $2,038,064 in earnings in seventeen career starts. In addition, he won the 1999 Eclipse award as Horse of the Year and Champion 3-Year-Old Colt.[27]

Charismatic poses for a photo during his short time at Old Friends. Tragically, he died less than three months later at the farm. *Courtesy of author.*

Upon retirement, he stood at Lane's End Farm before being sent to Japan in 2002 to continue his stud career. During his time in Japan, Michael Blowen kept his eye on him and let them know that when his stud career was over, he would like to bring him to Old Friends.

Because of the goodwill Michael had developed with the Japanese, when Charismatic's stud career was over, they contacted him to let him know that if he was still interested, they were ready to send Charismatic to Old Friends. "This is yet another dream come true," said Michael. "Charismatic holds such special memories for so many racing fans, so it's particularly meaningful to be able to bring him home."[28]

Arrangements were made, and thanks to the help of Narvick International, Megumi Igarashi, the JBBA's Kaori Matsuda, Tito's Handmade Vodka in Texas and the Lewis family, Charismatic came home. The Lewis family helped bring their other horse, Silver Charm, home as well.

"My family and I are so pleased to learn that our Horse of the Year Charismatic will be returning from Japan, and will be joining our beloved Silver Charm at Old Friends," said Beverly Lewis, who campaigned the horse with her late husband, Robert. "Charismatic's star shone very brightly, though only for a few weeks in 1999, when he won the Derby, the Preakness, and took a shot at Triple Crown immortality. Unfortunately, he was injured in that last race and was never able to run again, but now we are all looking forward to visiting him when he arrives!"[29]

———

Saturday, December 3, 2016

The lights from the new barn at Old Friends glowed bright on this chilly winter night, but it was warm inside as people gathered to await the arrival of the farm's newest retiree.

A little after 6:00 p.m., a horse van drove up to the barn. The driver got out and opened the van's doors, and in short order, out walked Charismatic. It was seventeen years after his 1999 Triple Crown season, but he looked beautiful and in great health as he looked around his new home.

The next morning, his former trainer, Hall of Fame inductee D. Wayne Lukas, drove to Old Friends from Louisville to see his old friend. Lukas was very impressed with how well the twenty-year-old stallion looked and joked, "Maybe we can run him again."[30]

A little later that Sunday, Charismatic was let out into his quarantine paddock, and he trotted around his new home. With his head held high, he seemed to glide along the ground as he looked things over and greeted some of his horse neighbors—Danthebluegrassman on one side and fellow Kentucky Derby winner Silver Charm in the paddock in front of him.

Charismatic was home and would soon be greeting his fans at Old Friends.

————

There is, unfortunately, a sad ending to Charismatic's story. On Sunday, February 19, 2017, less than three months after his arrival, Charismatic died overnight.

According to an Old Friends press release that Sunday, "The stallion was discovered early this morning. Attending veterinarian Dr. Bryan Waldridge was immediately called to the scene, but the cause of death is unknown. The results of a full necropsy are pending."[31]

It was a very sad moment, as Charismatic had just completed his quarantine period and had recently been let out into his own paddock, where he seemed very content, grazing and greeting his fans.

On Tuesday, February 21, 2017, according to a follow-up Old Friends press release, while the full necropsy report had not been finalized, a cause of death was determined to be a severe catastrophic fracture of his pelvis that resulted in fatal bleeding. "Fatal pelvic factures are uncommon and usually unforeseeable. It is not possible to know exactly how the injury happened or any factors that may have led to its occurrence."

Then, in a February 21, 2017 article on Paulick Report, Old Friends equine vet Dr. Waldridge said, "That injury would have occurred in minutes to seconds, so if you were on the other end of the barn, other than hearing the injury, that was all you were going to do, was hear it and see it. And no amount of intervention, short of divine intervention, was going to save the horse."[32]

While still grieving, Michael sent out a newsletter on February 21 that eloquently summed up what many of Charismatic's fans were feeling:

Sometimes the gods are just plain cruel. After more than a decade of working with the Japanese Bloodstock Breeders Association planning for the day when Charismatic could return to his fans in America, the dream finally came true. Last October, when Kaori Matsuda e-mailed me that Charismatic could retire to Old Friends, it was one of the greatest moments

of my life. Then, when he arrived in December, he was as kind and beautiful and majestic as you could ever imagine. When D. Wayne Lukas arrived the next morning, he concurred. Life just never gets better than those infrequent moments when fantasies become reality.

And, then, it all ended with a pre-dawn knock on the door and Tammy [Crump] *screaming, "Charismatic's dead." It ended as quickly as the snap of Charismatic's pelvis. We are left, of course, with memories that only he could have so generously left us. His proud brown eyes. His flashy chestnut coat and four white socks, and a self-assurance that only comes with winning the biggest races on the biggest stages. As Lukas has often said, "You'd better dwell on the positives or the negatives will eat you alive." I'm sure he gave the same advice to Charismatic.*[33]

Chapter 6

GAME ON DUDE

*I*t's funny how things work out sometimes. While Old Friends is now home to Triple Crown winners in Silver Charm and War Emblem, and while both have big fan bases, it is Game On Dude who is one of the farm's biggest attractions.

People come from all over to see the beautiful bay Thoroughbred, and he doesn't disappoint any of them. He's friendly, has a wonderful personality and will always come to the fence when a tour or someone stops by to visit. And yes, he does love carrots.

His popularity is probably due to the fact that he is one of the more recent big-name horses at Old Friends, so more people are familiar with him and his racing career. "It opened us up to a whole new fan base," said Michael Blowen on October 7, 2014, the day Game On Dude arrived. "A lot of the horses we have here, I remember racing, but a lot of people are too young to remember. He brings us a whole new group."[34]

———

Foaled in Kentucky on April 26, 2007, Game On Dude ran most of his races in California. People just loved to watch him race because he gave everything he had every time out. Because of that, his fans loved him.

A gelding, Game on Dude raced until he was seven years old. Usually, you can say that a horse had his best year in a single year, but that's not the case with him. He had several good years.

In 2010, as a three-year-old, he raced twice and had one win—the Lone Star Derby (G3) at Lone Star racetrack—earning $217,258.

In 2011, as a four-year-old, he ran three times, won three times and earned $1,917,400. His biggest wins were the Santa Anita Handicap (G1) and Goodwood Stakes (G1), both at Santa Anita.

In 2012, as a five-year-old, he raced seven times, won five times and earned $997,500. His biggest wins were the Hollywood Gold Cup Handicap (G1), the California Stakes (G2) and the Native Diver Stakes (G3), all at Hollywood Park, as well as the Awesome Again Stakes (G1) and San Antonio Stakes (G2), both at Santa Anita. He also ran in the 2012 Dubai Golden Shaheen and finished in sixth place.

In 2013, as a six-year-old, he once again raced seven times, won five times and earned $2,575,735. His biggest wins included his second win in the Santa Anita Handicap (G1) at Santa Anita and repeat wins in the Hollywood Gold Cup (G1) at Hollywood Park and the San Antonio Stakes (G2) at Santa Anita. He also won the Pacific Classic (G1) at Delmar and the Charles Town Classic Stakes (G2) at Charles Town Races.

In 2014, as a seven-year-old, he raced five times and earned $791,000 but won only one race—the Santa Anita Handicap (G1) at Santa Anita—which made him the only horse to win that race three times.

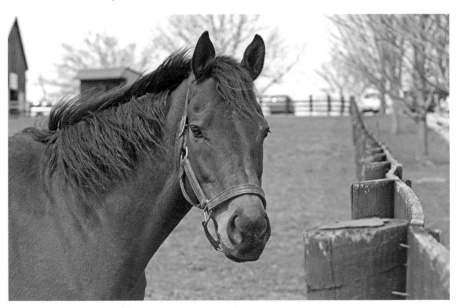

Game On Dude is ready to greet a tour heading toward his paddock. *Courtesy of author.*

Game On Dude was retired on September 18, 2014, with sixteen wins, seven seconds, one third and $6,498,893 in earnings in thirty-four career starts.[35]

His ownership—which consisted of the Lanni Family Trust; Mercedes Stables; Bernard Schiappa; Joe Torre, former New York Yankee manager and baseball Hall of Famer; and his trainer, Bob Baffert—began looking for a place to retire him. Into that mix came Michael, who was hoping to bring him to Old Friends:

> *I knew they were going to retire him, and I really wanted him to come to Old Friends. He was such an important horse for us because he's young and because he would bring a whole different group of fans here. You know, my generation is well represented by Silver Charm, War Emblem, Charismatic, Alphabet Soup, Sarava and Touch Gold and all these great horses. But there's a lot of younger people who've only seen those races on TV. They never experienced them close. But Game On Dude raced for so long in California, he's a future Hall of Famer, and I just knew he was going to be really great for us.*
>
> *So, I made my pitch, and then I got several calls from Jill Baffert* [wife of Bob Baffert], *several calls from Bob Baffert, several calls from Bernie Schiappa—all the owners. It seemed more complicated than going through an IRS audit.*
>
> *But to their credit, Game On Dude came to us in better shape than any horse we've ever had off the track—ever. He was in absolutely spectacular condition. And he has attracted a great audience. He's got a great personality, too. He's very easy to deal with. He's never had an aggressive moment in his life toward anybody that's come to visit him. Little kids can hug him and kiss him....He's just been a tremendous addition.[36]*

In May 2015, Game On Dude, who is in a paddock with his buddy Catlaunch, had some special visitors, as the Bafferts came to the farm during the week leading up to American Pharoah's Kentucky Derby to see him and Silver Charm. It turned out that Game On Dude was Jill Baffert's favorite horse. Michael explained:

> *When Jill came, she sat out in the middle of the paddock with some carrots and some Jolly Ranchers* [his favorite treat]. *She spent almost all the time they were here with her favorite horse, Game On Dude.*

When Bob eventually got here the Tuesday before American Pharoah's Derby, he told me that he was really surprised at how this place looked. He expected to see thirty horses on one acre of ground and just hanging around and that kind of stuff....He didn't realize the place was as nice as it was. He was very complimentary, and we're just eternally grateful to him and all the people associated with not only Game On Dude but with all of his horses. He does a tremendous job.[37]

Since then, the Bafferts and the owners have been very generous to Old Friends. They even donated a new Kubota (a four-wheel-drive vehicle) to the farm, and Bob donated $50,000 to Old Friends after American Pharoah won the Triple Crown. "They are all very happy with Old Friends," said Michael. "And, we are eternally grateful to them."[38]

Chapter 7

AMAZOMBIE

*W*hen you arrive at Amazombie's paddock at Old Friends, you'll immediately see the connection between him and his paddock pal, Rapid Redux. The two have been buddies almost from the moment they were placed together.

It is a lot of fun to watch the two, as they are never more than a few feet from each other. If one walks away, the other follows. If one starts grazing, so does the other one. If they see a tour coming, together they make their way to the fence for a visit. Simply put, according to Michael Blowen, they are inseparable:

> *It took a little while for Rapid Redux to understand what the deal was, but it didn't take Amazombie long at all. Now they just adore each other. If one of them has to come in, the other one has to come in because they start screaming, "Where's my buddy? Where'd he go?" They have built up this amazing bond over the years. Amazombie and Rapid Redux are best pals.*[39]

Amazombie, who is by Northern Afleet-Wilshe Amaze, by In Excess (Ire.), was foaled in California on April 18, 2006.

He had a slow start to his racing career, but in 2011, as a five-year-old, everything came together for him, and he won five times and earned $1,327,000 in nine races. His biggest win that year was the Sentient Jet

Best buddies Amazombie, *left*, and Rapid Redux play together. *Courtesy of Laura Battles.*

Breeders' Cup Sprint (G1) at Santa Anita with his regular jockey, Hall of Famer Mike Smith, riding.

In addition, he also won four other stakes that year: the Ancient Title Stakes (G1), the Potrero Grande Stakes (G2) and the Sunshine Millions Stakes, all at Santa Anita, and the Tiznow Stakes at Hollywood Park. For his efforts, he was awarded the Eclipse award as 2011 Champion Male Sprinter.

In 2012, he continued running strong and in six races won two graded stakes: the Bing Crosby Stakes (G1) at Del Mar and repeated in the Potrero Grande Stakes (G2) at Santa Anita. He also ran in the Breeders' Cup Sprint again, but he did not place and was retired.

He finished his career with twelve wins, five seconds, six thirds and $1,920,378 in earnings in twenty-nine starts for the ownership partnership of Thomas C. Sanford and trainer William Spawr.[40]

Around the time Michael started making inquiries about Game On Dude, he also started asking about Amazombie. Soon, things were worked out, and on October 7, 2014, both Amazombie and Game On Dude arrived at Old Friends.

Today, Amazombie and Rapid Redux, who in 2011 tied Citation's record of nineteen wins in one season and retired in 2012 with the modern North American record of twenty-two wins in a row, enjoy their retirement together at Old Friends.[41]

Chapter 8

ALPHABET SOUP

*A*lphabet Soup is another beautiful gray horse that calls Old Friends home. With a sweet and friendly disposition, he has quickly become a favorite of tourists, as he comes right up to the fence to greet them every time. "Alphabet Soup is one of the kindest stallions we've ever had here," said Michael Blowen. "I don't know what it is, but he is just really, really kind. He likes people. He lets you pet him. He's like a big ol'puppy dog. He's better than most puppy dogs. He's not anxious. He's a lot like Silver Charm in that they've got a lot of class. I adore him."[42] While he might act like a "puppy dog" today, it hides the fierce competitor he was during his racing career.

———————

Alphabet Soup was foaled in Pennsylvania on March 31, 1991, and raced for four years between 1994 and 1997.

His best year came in 1996, when he won all seven of his races, including the San Antonio Handicap (G2) and the San Pasqual (G2), both at Santa Anita, and the Pat O'Brien Handicap (G3) at Delmar.[43] His year culminated with his win in the Breeders' Cup Classic (G1) at Woodbine, which was an exciting race as he squeezed between two horses—John Henry and Louis Quatorze—to win by the slimmest of margins.

Here's how the race unfolded, according to Alphabet Soup's jockey, Hall of Famer Chris McCarron:

Alphabet Soup, the winner of the 1996 Breeders' Cup Classic, looks out over his new home at Old Friends. *Courtesy of author.*

Alphabet Soup was a very generous horse with his talent, but he was also conservative....He was like a bicycle; if you're not pedaling, he's not going forward.

So, I was laying in third turning for home outside of Louis Quatorze, with Cigar on my outside.

The three of us went down there [down the stretch], *ding-donging it all the way to the wire. And Alphabet Soup was incredibly game. First of all, he's holding off Cigar on the outside, and then Louis Quatorze started to come back at him from the inside, and he was able to have enough stamina and enough courage to hold them both off. It was a well-fought fight.*[44]

At the wire, Alphabet Soup stretched his head out to beat Cigar by a nose and Louis Quatorze by a head. According to an article on BreedersCup.com, "Only a nose and a head separated those three at the wire. It took a track record time for Alphabet Soup to hold off Louis Quatorze and Cigar."[45] That record time for Alphabet Soup was 2:01 for the mile and a quarter.[46]

In a funny twist, Michael remembers that race. "I remember Alphabet Soup up at Woodbine when he was in the Breeders' Cup Classic in 1996

and he won a three-horse photo. He was right between Louis Quatorze and Cigar....And, of course, I bet on Cigar and Alphabet Soup beat me."[47]

The win was the final one of Alphabet Soup's career. In 1997, at age six, his best finish was a second in the San Antonio Stakes, a race he had won the year before. It was then decided to retire him to Adena Springs.[48]

At stud, he "sired 48 stakes winners, including Sovereign Champion Alpha Bettor; millionaire winner of the 2004 Dubai Golden Shaheen, Our New Recruit; and G1 winning filly Egg Drop. His progeny has amassed earnings of over $40.9 million."[49]

In 2015, at age twenty-four, Alphabet Soup was pensioned from stallion duty and, thanks to Frank Stronach, owner of Adena Springs, sent to Old Friends to enjoy his retirement.[50]

———

Even in retirement, Alphabet Soup is "hard at work," though it's nothing strenuous. You see, as with many gray horses, Alphabet Soup has developed melanoma. It's not deadly as it is with humans, but the tumors can become uncomfortable. Thanks to Old Friends veterinarian Dr. Bryan Waldridge, a new treatment has been developed by Veterinary Oncology Services–Morphogenesis, and it seems to be helping the old boy. According to a January 9, 2017 article by Frank Angst on BloodHorse.com:

> A cutting-edge cancer treatment has helped reduce skin cancer in 1996 Breeders' Cup Classic (G1) winner Alphabet Soup, who recently celebrated his 26th birthday at Old Friends Equine retirement home near Georgetown, Ky.
>
> The cancer treatment, developed by Veterinary Oncology Services–Morphogenesis, is a vaccine that allows Alphabet Soup's immune system to target the melanoma. Since skin cancer cells were first collected in mid-July for use in developing the vaccine and eight treatments that followed, veterinarian Dr. Bryan Waldridge, of Park Equine Hospital, has seen a reduction between 75 percent and 80 percent in the cancerous masses that had developed near his tail.
>
> "We're hoping the immune system will stay after that cancer. We're hoping for a progressive shrinkage," Waldridge said. "I would think it would be months in the future until we know where we're going to get to, but it's gone down enough that I wouldn't be shocked to see this totally go away."
>
> Old Friends founder Michael Blowen has seen Alphabet Soup in better spirits in the paddocks as the treatment has reduced the cancer. The

treatment is being funded by the son of Cozzene's former residence at stud, Frank Stronach's Adena Springs.[51]

On a beautiful Kentucky afternoon, Alphabet Soup can be seen peacefully grazing while waiting for the next group of tourists to arrive so he can get some carrots. Such is the happy life of a retired Thoroughbred at Old Friends.

Chapter 9

ELDAAFER

The arrival of Eldaafer at Old Friends falls into the category that Michael Blowen likes to call the "You just can't make this stuff up" category. It began just before Eldaafer arrived at Old Friends, as Michael explained:

> I got a call from my friend over in Lexington at Brookledge Horse Vans layover facility on a Friday night, and my friend said, "Can I bring that horse over tomorrow?"
> I said, "Yeah."
> He said, "I'll bring him and his friends."
> I said, "His what?"
> He said, "He's got two goats; they're his friends."

According to Michael, "When Eldaafer's trainer, Diane Alvarado, called and asked if we'd like him, I said, 'Yeah, that's great.' I don't remember her mentioning anything about his friends. Now, she might have mentioned it, but I think I would have remembered if she did. But, I don't. I was too excited about getting the horse."[52]

The next day, the van arrived at Old Friends, and Eldaafer was led down the ramp. When he got to the bottom, he stood there and looked around at his new home. Right behind him, two goats, Google (a slightly gray goat) and Yahoo (mostly white), came down the ramp and stood by his side.

Ever since, they have always been close together. In fact, during the first few days, whenever Eldaafer was turned out, it was a fun dance to watch as

Google and Yahoo would walk next to him, behind him and, sometimes, cross right under him, as the big horse made his way out to the round pen next to the barn.

As Michael likes to say, "He's kind of like the president and they're like the secret service."

———————

Eldaafer, who is by A.P. Indy-Habibti, by Tabasco Cat, was foaled in Kentucky on March 13, 2005. He began racing as a three-year-old in 2008 and finished as an eight-year-old in 2013.

During his career, he won a number of graded stakes races, which included the Brooklyn Breeders' Cup Handicap (G2) at Belmont in 2009, the Turfway Park Fall Championship Stakes (G3) in 2010 at Turfway Park, the Brooklyn Handicap (G2) at Belmont in 2012 and the Greenwood Cup Stakes (G3) in 2013 at Parx Race Track.

It was at the Turfway Park Fall Championship Stakes (G3) in 2010 at Turfway Park in Kentucky when his handlers began to realize how attached Eldaafer was to his goat Google.

Eldaafer, the 2010 Breeders' Cup Marathon winner, and his two pals, Google, *right*, and Yahoo, are always together. *Courtesy of author.*

According to Michael in a story he likes to tell, they shipped Eldaafer to Kentucky for the race:

> *I guess when they got him there, Eldaafer was going out of his mind. He was pacing in his stall. So, they called back to Florida and said, "Look, this horse can't run in this race. He's going nuts."*
>
> *They said, "That's funny, the goat's acting up too."*
>
> *So, they sent the goat up to Cincinnati on a plane, brought it to Turfway Park and put him in [the stall] with Eldaafer.*
>
> *The result: Eldaafer settled down, Google settled down and Eldaafer went out and won the race, which punched his ticket to a second chance in the Breeders' Cup Marathon (G3).* [He also ran it in 2009 at Santa Anita Park and finished seventh.][53]

The 2010 Breeders' Cup race turned out to be the biggest win of Eldaafer's career, and it came in exciting fashion as the now five-year-old Thoroughbred came from behind and won the race at Churchill Downs by 1-3/4 lengths. "Oh my God, I'm so proud of him, he's done everything right all year," Alvarado said of Eldaafer in a *Blood-Horse* article at the time. "This means everything to me, I can't even think of what I'm feeling right now."[54]

Now, there's two interesting things to point out about the race. First, Eldaafer set a track record time of 2:59.62 in the 1-3/4-mile race on Churchill's main track, which was rated Fast. (The previous mark was set in 1995 by Caslon Bold.)[55] Second, while it was the biggest win of Eldaafer's career, not many people remember it because it was remembered mostly for a fight between two jockeys—Calvin Borel and Javier Castellano—in the winner's circle after the race, which was shown "live" on television.

Eldaafer continued racing as a seven-year-old and won the Carl Hanford Memorial Stakes at Delaware Park in 2012, and as an eight-year-old, he won the Greenwood Cup (G3) at Parx Racing.[56]

His race career ended after he suffered a suspensory injury during a routine work at Gulfstream Park in November 2013. He finished his career with thirteen wins, three seconds, seven thirds and $1,031,835 in forty-six career starts.[57]

He came to Old Friends thanks to Alvarado, who worked with Old Friends to ensure Eldaafer's well-being until he arrived at the farm. In May 2014, the champion settled in at Old Friends with his longtime companions, Google and Yahoo.[58]

As Eldaafer settled in at Old Friends, he enjoyed his days outside in the round pen next to the barn. Each day, Eldaafer would be let out into the round pen, and Google and Yahoo would follow along and go out with him. Each night, the three would come back in and spend the night in the big stall together.

After a while, it was time to allow Eldaafer to go into a bigger paddock so he could run and stretch his legs. The paddock in front of Michael's house was chosen, and Eldaafer, Google and Yahoo seemed to enjoy their days stretching their legs in the bigger paddock. It looked like everyone was happy.

Well, almost. "One Saturday morning, Dr. [Doug] Byars [Old Friends' first equine veterinarian, who passed away on July 8, 2014] and I came back from doing Ercel Ellis's radio program [*Horse Tales*], and Google had slipped under the fence of the big paddock and was loose and walking around at the top of the farm near the house," said Michael. "And Eldaafer was going out of his mind because the goat was loose and he wasn't in the paddock."[59]

Well, it took a little while, but they finally caught Google and reunited him with Eldaafer and Yahoo, and all three settled down.

Today, Eldaafer, Google and Yahoo live in their own private, specially made paddock on the farm annex right next door to the main farm. "We knew we couldn't put Yahoo and Google in a regular fence because they'll slide out and escape again," said Michael. "So that's when Mark Otto, who's now the treasurer of Old Friends, donated a bunch of Red Brand 'V' Mesh fence that we could put around [a paddock] so the goats couldn't get out from under it. That also started our whole association with 'V' Mesh, Mark Otto and Red Brand. And, it's worked out really good."[60]

Once the paddock was set up, one last thing needed to be done. "Dr. Waldridge, Old Friends' current equine veterinarian, was concerned for the goats," said Michael. "You know, you don't have to really worry about coyotes or anything with these horses. Coyotes are not interested in these horses. But Dr. Waldridge was concerned that coyotes might be interested in one of the goats. So, we had to build a special goat house for the goats right in Eldaafer's run-in shed, so we could put them in there at night. That way, if the coyotes came by, they wouldn't be able to get at Eldaafer's pals. So, they get put in there every night."[61]

Eldaafer and his goat buddies get visits and carrots and just enjoy all the attention.

So there you have it, the story of Eldaafer, a Breeders' Cup champion, and his two goat pals—Google and Yahoo—who arrived at Old Friends somewhat unexpectedly, along with their special paddock, complete with a goat house. As Michael likes to say, "You just can't make this stuff up."

TINNERS WAY

*E*very once in a while, usually in the fall around the time of the Secretariat Festival in Paris, Kentucky, Tinners Way gets a special visitor. He arrives at Old Friends quietly but always with a big smile and respectfully asks if he could please see Tinners Way. The visitor is Charlie Davis, the former exercise rider for Tinner's sire, Secretariat.

In Tinners Way, Charlie not only gets to visit a great racehorse, but maybe it also gives him a little connection back to his time with Secretariat.

———

Foaled in Kentucky on May 25, 1990, Tinners Way is by Secretariat-Devon Diva, by The Minstrel, and according to the Old Friends website, he was "Secretariat's final colt and one of his very best."[62]

In 1993, at age three, Tinners Way raced in England and won City of York Stakes and the Milcars Temple Fortune Stakes on the turf. He also placed in some other races in England and France.

Then in 1994, at age four, he came back to the United States and, trained by Bobby Frankel, had the best season of his career, winning two times, finishing second four times, third one time and earning $756,050 in ten races. His biggest win came at Del Mar, where, with jockey Eddie Delahoussaye riding, he won the Pacific Classic Stakes (G1).

In 1995, at age five, Tinner won his second straight Pacific Classic, once again with Frankel training and Delahoussaye riding. Then, in his final year

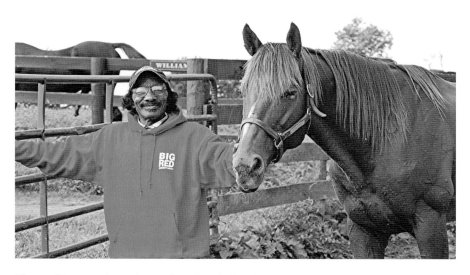

Tinners Way, two-time winner of the Pacific Classic, gets a visit from Charlie Davis, former exercise rider of Secretariat. *Courtesy of author.*

of racing, 1996, Tinner won the California Stakes at Hollywood Park and tied the track record of 1:45-3/5 in the 1-1/8-mile turf race.

Tinner was retired in 1996 with seven wins, six seconds, four thirds and $1,849,452 in earnings in twenty-seven career starts.[63] He began his stud career at Vinery in Kentucky. When his stud career ended in 2010, he was standing at Joe and Sharon Kerby's Key Ranch in Texas. He arrived at Old Friends in September 2010 thanks to Phil Leckinger, who had acquired him to stand at Key Ranch.[64]

When Tinners Way first arrived at Old Friends, he was placed in one of the front paddocks but was always very nervous, constantly running around his paddock. He just never seemed comfortable.

Then he was placed in one of the paddocks at the back of the farm, across from Williamstown, a son of Seattle Slew. While still nervous, he slowly settled down and enjoys his days grazing, hanging his head over his fence and "talking" to horses in the paddocks close to his.

While his paddock is not along the regular tour route, if someone asks to see him, a tour guide is always happy to take them back to see the beautiful chestnut stallion. And Tinner is always happy to get visitors, too, because he likes the attention and he really loves carrots.

Sadly, on July 5, 2017, Tinners Way had to be euthanized due to acute onset of severe neurological disease. He was twenty-seven.

Chapter 11

GENUINE REWARD

On a sun-bathed late afternoon at Old Friends, Genuine Reward can usually be seen grazing peacefully in his paddock with not a care in the world. This peaceful scene, however, is a far cry from the whirlwind of activity that swirled around him on social media in the weeks leading up to his arrival at the farm. It seemed someone had unknowingly listed him for sale on Craigslist for $500 in the hopes of finding him a nice home to retire. What that person didn't know was that kill buyers find that price attractive.

At that moment, it appeared Genuine Reward might be at risk. As a result, a number of people, including a well-known author, began to work to try and get him to Old Friends. Before telling that story though, it is important to first talk about Genuine Reward's mom, the 1980 Kentucky Derby (G1) winner Genuine Risk.

———

Genuine Risk, who was by Exclusive Native-Virtuous, by Gallant Man, is one of only three fillies to ever win the Kentucky Derby. (The other two were Regret in 1915 and Winning Colors in 1998.)

Born in Kentucky on February 15, 1977, she was trained by LeRoy Jolley and campaigned by Diana Firestone.[65]

In 1980, Genuine Risk had her best year of racing, and her fan base began to grow. Not only did she win the Kentucky Derby at 13-1 odds,[66] but she also finished second in the Preakness Stakes (G1) and Belmont Stakes

(G1), the best finishes of any filly in all three Classics in history. She also won the Ruffian Handicap (G1) later that year at Belmont. With those results, she received the 1980 Eclipse award as Champion 3-Year-Old Filly.

In 1981, she ran only three times and on August 10, 1981, won an allowance race at Saratoga. It was her final race. At retirement, she had ten wins, three seconds and two thirds and $646,587 in earnings in fifteen career starts. Then, in 1986, she received the ultimate honor when she was enshrined in the Thoroughbred Racing Hall of Fame.[67]

With her racing days behind her, Genuine Risk began her breeding career. Sadly, over the years, she had problems producing a live foal. However, two times she was able to carry a foal to term. The first was in 1993 with the birth of Genuine Reward. The second was in 1996 with the birth of Count Our Blessing, by the sire Chief Honcho.

The birth of her first foal made her fans ecstatic. They had been following her breeding career and were happy for her when Genuine Reward was born. If you look at photos of her with him, you can see a loving mother watching over—almost doting over—her young baby.

In 2000, Genuine Risk ended her broodmare career and went on to enjoy her days at the Firestone Farm. She died peacefully in her paddock on

Genuine Reward, one of only two sons of 1980 Kentucky Derby winner Genuine Risk, enjoys his paddock. *Courtesy of author.*

August 18, 2008. She was thirty-one years old. Interestingly, she died "several months after the death of the last Derby-winning filly, Winning Colors."[68]

As to her foals, neither one ever raced. At age four, Genuine Reward was sent off to stud at Blue Ridge Farm in Virginia.[69] This brings us back to his story.

———

Genuine Reward was foaled on May 15, 1993, in Kentucky and was by Rahy-Genuine Risk, by Exclusive Native, and like his mom, he was trained by LeRoy Jolley. However, he never raced and was sent to stud in 1997. There, he produced some winners but never a stakes winner.

Eventually, in 2002, he ended up in Sheridan, Wyoming, where he was very successful in producing polo ponies. He remained there until 2015, when his owner decided to try and find him a nice home to retire. To do so, she unwittingly listed him on Craigslist for $500, figuring the price would give some nice folks a chance to buy a good horse. What she didn't know was that the price was one that would attract kill buyers.

Soon, social media lit up with word that the owner of the son of Genuine Risk was trying to sell him to kill buyers on Craigslist. The woman who listed him did not know what she was in for. "This poor woman got eviscerated on the Internet," said Michael Blowen. "She didn't really know about Craigslist or what happens to a lot of horses there. She was totally innocent....She wouldn't do anything that would have hurt this horse, I'll tell you that. She's already been here to see him."[70]

Soon the news spread, and it caught the attention of award-winning author Laura Hillenbrand, who wrote *Seabiscuit: An American Legend* (2002) and *Unbroken: A World War II Story of Survival, Resilience, and Redemption* (2014). It turned out that Genuine Reward was very special to her, as his mother, Genuine Risk, first got her interested in racing. That was why she was determined to rescue him and get him to Old Friends. In an e-mail interview, Laura explained:

> *Genuine Reward was especially precious to me because of the gift his mother gave me. On a May afternoon when I was 12, I turned on the TV and watched a copper juggernaut of a filly named Genuine Risk win the Kentucky Derby. Her puissance, her grace, the absolute command she had over the colts she trounced, had me enthralled. That filly hooked my heart on racing. The next morning, I was cutting articles on her out of the*

Washington Post and taping them to my bedroom walls, the beginning of a habit that would end with the entirety of all four walls, and part of my ceiling, papered over in racing clippings.

Two weeks after the Derby, my sister Susan and I arrived at Pimlico well before dawn to claim a spot at the finish line and watch Genuine Risk finish a gallant second in her wildly run, controversial Preakness. We were crouched by the TV, cheering her on, as she again claimed second in the Belmont. I followed her through her racing career and her broodmare life, mourning her losses of foals, and celebrating when she at last gave birth to her first live foal—Genuine Reward. When she lay down in her paddock and died at the grand age of 31, my heart sank a little.

Genuine Risk put racing into my blood, and that was a tremendous gift. I have come to love so many racehorses, but she will always be the first. When I learned her son was at risk, decades after I first saw her gold body streak across my TV screen, I felt I owed it to her to do my best to see that he was safe.[71]

As soon as Laura learned about the listing of Genuine Reward on Craigslist, she knew she had to try and do something:

I was sitting in my office in Washington, DC, blow-drying my hair while scrolling through Facebook, when I saw a post showing a Craigslist ad for a chestnut stallion in Wyoming. I clicked on it and saw the horse's name: Genuine Reward. I hadn't thought of the horse in so many years, but instantly remembered him. He looked radiantly beautiful, and it was at first so nice to see him. But when I saw the asking price, I gasped: $500 or best offer. I knew that at that price, he ran a huge risk of being snapped up by a killer buyer and sent to a slaughterhouse.

I literally dropped my hair dryer, grabbed my phone, and called Michael Blowen at Old Friends. I've long been an ardent supporter of the farm, and knew that Michael would do his best to help. He was out in the field when I called, but someone got me through to him. I think I was speaking so fast that my words were tumbling over themselves, but I knew time was very much of the essence. I was terrified that I was too late. I told him I'd buy the horse and pay whatever it took to get him from Wyoming to Old Friends, if they could take him. Michael had already heard that the horse was at risk, and was working on what he could do. He happily said yes to my offer. He called me back later and told me the owners had agreed, and I dropped back in my chair in relief and gratitude. I immediately sent Old

Friends $5000 to cover whatever needed paying for. The owners ended up donating him for free, which was lovely of them.[72]

Genuine Reward arrived at Old Friends in 2015 at age twenty-two, and Michael fell in love with him almost immediately. "He's another horse who's really smart," said Michael. "He was never a great racehorse or anything, but he is very, very smart. And he looks like his mother, Genuine Risk....He's just really beautiful."[73]

After Genuine Reward was settled into his stall, the first call Michael made was to Laura:

Michael called me when Genuine Reward arrived at Old Friends. He'd fallen in love with the horse from the first, and was astonished at how youthful he looked for his 22 years. He told me about the horse's adoring nature, and a little trick he pulled that hinted at his keen intelligence. Michael brought him a bucket of carrots. He was feeding them to the horse by hand, and after eating some, Genuine Reward took the rest, one by one, and dropped them into his feed bucket to save for later. I was so charmed, and hoped one day I'd be able to meet this horse.[74]

According to Michael, in the first days of his arrival, Genuine Reward received a number of visitors, including his former trainer, LeRoy Jolley. Trying to ensure horses a safe home upon retirement has long been part of Laura's work in her life, starting from when she was very young:

My first horse, who came to me when I was 13, was an emaciated filly my sister and I pooled our life's savings to buy from a man who was selling her to slaughter. That experience was my introduction to the horrific business of slaughter, and the dark fates that await so many horses. Since then, I've bought and rehomed about 15 horses who'd been condemned to kill pens. Most were Thoroughbreds, but I've rescued everything from a pair of massive Percherons to a little pinto pony.[75]

A few months later, Laura and a friend were making a cross-country trip with many stops along the way. One of the first stops was Old Friends in Kentucky, where she got to see Genuine Reward and the other horses. It all turned out to be a very memorable experience for her, as she explained:

A few months after Genuine Reward arrived at Old Friends, I undertook a 4,300-mile road trip across America, to my new home in Oregon. There were many places I wanted to see along the way, but the one I could not miss was Old Friends. I wanted to give Michael Blowen a very long-awaited hug, and I wanted to meet Genuine Reward. Going south to Kentucky would greatly lengthen the trip, a formidable undertaking for someone in difficult health, but this meant too much to me to pass up.

Our intent was to stop at an RV park near the farm, visit for an hour or so, then move on. But because it was Breeders' Cup week in Kentucky, all the RV parks were full. I called Michael and told him we were having trouble finding a place. He invited me to park the RV at the farm, right next to the barn where Genuine Reward lived with Silver Charm and several other horses.

We arrived in the evening, and Michael ran from his house and gave me that long-promised hug. After a paddock visit with Gulch, another horse beloved to me, we went into the barn, and there was Genuine Reward, looking incandescently lovely and so much like his mother. He was as sweet as Michael had told me he was, hurrying to his stall door and bending his head and neck around my body in a big, sloppy hug. I threw my arms around his neck and hugged him back, fighting back happy tears.

That night we slept only feet from Genuine Reward, lying awake and listening to him and his barnmates snort and stir in their bedding. In the morning, Genuine Reward was turned loose in a huge, grassy paddock that runs alongside the entrance road to the farm. He had assigned himself the role of Old Friends' goodwill ambassador, rushing up to greet each of the many car- and busloads of visitors that streamed up the road. Unable to tear ourselves away from this joyful place, we stayed all day, and well into the next, enjoying Genuine Reward's antics. He adored everyone he met, nuzzling each person in turn. I've never seen a horse more joyful, or more smitten with people, than this one. There was no one he loved more than Michael, who would cruise by his paddock to soak up some love each time he went up and down the road.

When we drove out of the farm, Genuine Reward was grazing in his paddock. He'd been merrily rolling on the ground after an overnight rain, and was happily caked in mud. I jumped out of the RV and called to him. He raised his head and ran to the fence, thrust his head over the top rail, and buried his muddy face in my chest. I fed him peppermints and posed for a photo of my last moments with him. He was, as always, all affection. When we drove off, he stayed by the fence, watching us go. I'm so happy I saw that ad.[76]

While Laura received a lot of credit for helping get Genuine Reward to Old Friends, she is modest and deflects the credit to others. However, out of all this, she added some cautionary thoughts:

> *People have been so kind in showering me in thanks for "saving" Genuine Reward, but I don't deserve such credit. Someone on Facebook, a stranger to me, found the ad and posted it there, and she deserves everyone's gratitude for getting the horse's situation publicly known, to me and to others. And by far the most credit goes to Michael Blowen and all the extraordinary people at Old Friends, who welcomed the horse and gave him an idyllic life, one enjoyed by all of the horses at their splendid farm.*
>
> *Also, I hope that no one vilifies the people who put the horse up for sale. Like many well-meaning horse owners, they almost certainly didn't realize the price they were asking was putting the horse at risk, and were only hoping to make him affordable for someone with a good home. I've corresponded with them, and they are very kindhearted people who love the horse very much, and it's clear from the horse's condition and disposition that he was beautifully cared for.*
>
> *I hope that one lesson everyone can draw from this is that it is vitally important to price sale horses above that which makes them vulnerable to slaughter buyers, who often masquerade as horse loving people just looking for a pet, sometimes going as far as to bring children along as props. A safe asking price is $1,000.*[77]

Today, Genuine Reward lives in the paddock at the front of the farm that was previously the home of Gulch and Fortunate Prospect. There, along with Sarava, they are some of the first horses people see on a tour.

When that happens, Genuine Reward really gets excited as he heads to the fence to greet his visitors. He's quickly figured out that visitors mean carrots, and he happily gobbles up as many as he can while the tour guide tells his story—in his case, it's a story with a very happy ending.

Chapter 12

BONAPAW

*I*t was Saturday, September 21, 2002, and 8,452 fans were in the Belmont Park stands for the Vosburgh Stakes (G1). On the track was Bonapaw, owned by twin brothers James and Dennis Richards, who were there cheering on their horse as he charged down the stretch in the lead under jockey Gerard Melancon. It looked like Bonapaw might finally get his first Grade 1 stakes victory.

Bonapaw had taken the Richards brothers on a wonderful journey ever since they purchased him for $6,500 at the 1997 Keeneland Yearling Sales. And now, as the sleek, bay Thoroughbred ran toward the finish line, it looked like their dream journey might finally include a Grade 1 stakes win. What they didn't know is that their journey was also coming to an end.[78]

―――――――

On a cool September morning at the 1997 Keeneland Yearling Sales, James Richards was walking around the barns with his wife, Mercedes. After purchasing a Thoroughbred earlier in the sale, James wanted to get another one.

As he was walking around, something off to his side caught his attention, and when he looked over, he saw a horse with his head out of his stall looking right at him. For some reason, that horse drew James's attention. "He just got a chill that went down his spine that he never, ever in his life felt before," said James Richards Jr., explaining what his father told him about that moment.[79]

James started to walk over to the horse, but a man in the barn called out and told him to be careful—he was a mean horse. But James didn't listen. "My dad walked right up to the horse, [and] the horse put his head on his shoulder like they knew each other," said James Jr. "My dad looked at my mom and told her, 'Merc, I don't care if this horse costs $50,000. I'm buying this horse.'"[80]

James called his twin brother, Dennis, and asked him what he thought if he came home with a second horse. Dennis wasn't for it, but James was determined, and when the horse entered the sales ring, James won the bidding and got the horse for $6,500. Little did he know the horse he just purchased, named Bonapaw, would give him and his brother some of the greatest thrills of their horse racing lives.

———

Bonapaw won his first race in his fourth start. It was a Maiden Special Weight at Fair Grounds on November 27, 1998, and it wasn't really that spectacular. But the wins kept mounting up, and the brothers just enjoyed the ride.

They also knew they were blessed with this wonderful horse and decided to share the winnings, which they did with the Children's Hospital of New Orleans. The hospital was a favorite charity of the twins' father as well.

Bonapaw seems to be saying, "Welcome to my world," as he poses for this photo. *Courtesy of author.*

Michael Blowen; his wife, Diane White; and his buddy, Little Silver Charm, pose with their 2014 Special Eclipse award given to Old Friends. *Courtesy of author.*

Michael Blowen visits Silver Charm, his favorite horse at Old Friends. *Courtesy of author.*

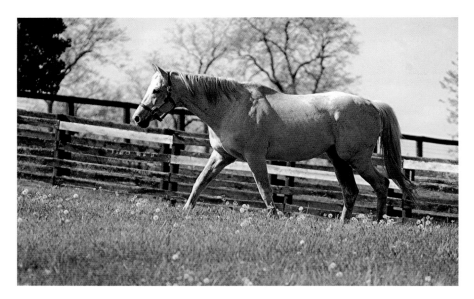

Silver Charm, the 1997 Kentucky Derby winner, walks along the fence of his paddock on a beautiful afternoon. *Courtesy of author.*

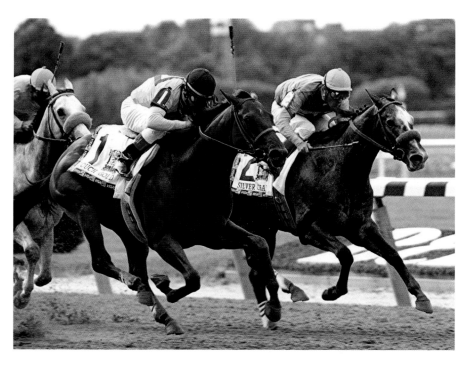

Touch Gold, *left*, won the 1997 Belmont Stakes over Silver Charm, *right*, and denied him the Triple Crown. *Courtesy of Adam Coglianese.*

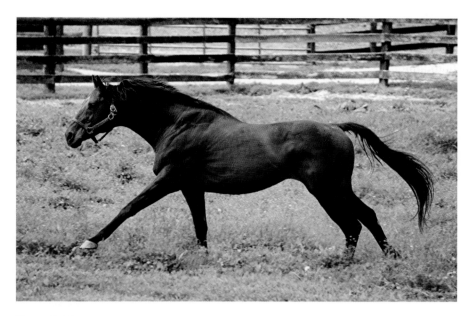

Touch Gold runs to his fence to greet a tour. *Courtesy of author.*

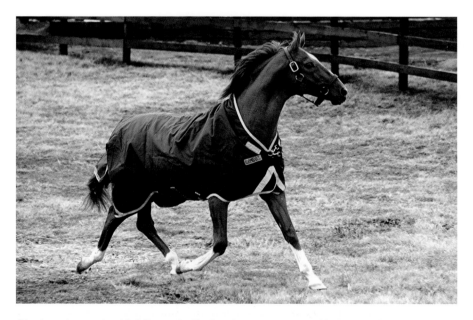

Charismatic was the third Kentucky Derby winner to come to Old Friends. Sadly, he died a few months later. *Courtesy of author.*

Left: War Emblem was the second Kentucky Derby winner to arrive at Old Friends. *Courtesy of author.*

Below: Sarava won the 2002 Belmont Stakes, a race that denied War Emblem the Triple Crown. *Courtesy of author.*

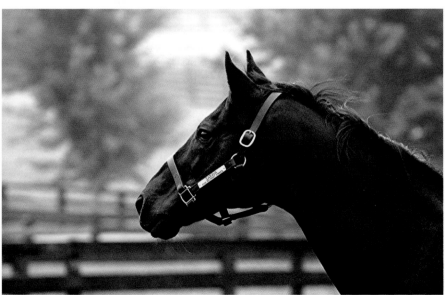

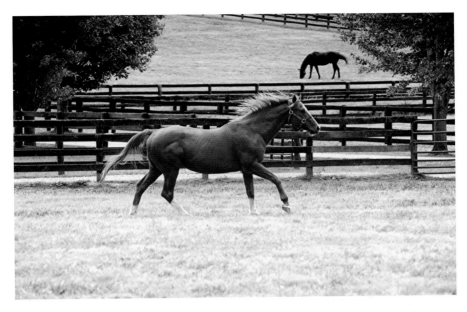

Genuine Reward, one of two foals out of Kentucky Derby–winning filly Genuine Risk, came to Old Friends with help from award-winning author Laura Hillenbrand. *Courtesy of author.*

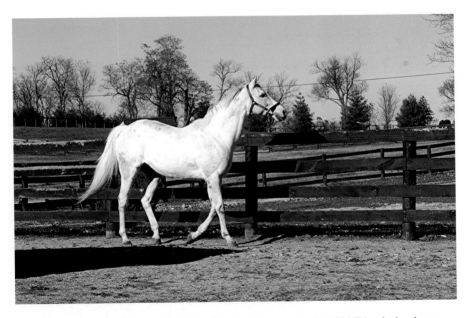

Alphabet Soup, the 1996 Breeders' Cup Classic winner, retired to Old Friends thanks to Frank Stronach's Adena Springs. *Courtesy of author.*

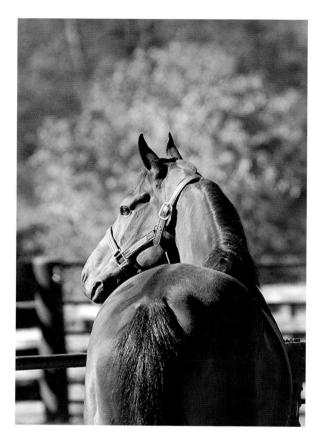

Left: Game On Dude, a three-time winner of the Santa Anita Handicap, now calls Old Friends home thanks to Bob and Jill Baffert. *Courtesy of author.*

Below: Amazombie, the winner of the 2011 Breeders' Cup Sprint, enjoys his retirement at Old Friends. *Courtesy of author.*

Little Mike, winner of the 2012 Breeders' Cup Turf, came to Old Friends after a spectacular racing career. *Courtesy of Laura Battles.*

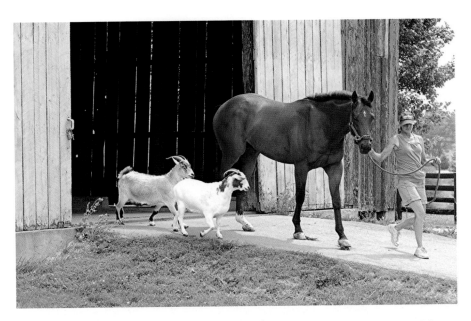

Eldaafer, winner of the 2010 Breeders' Cup Marathon, is never far from his goat buddies, Google (gray) and Yahoo (white). *Courtesy of author.*

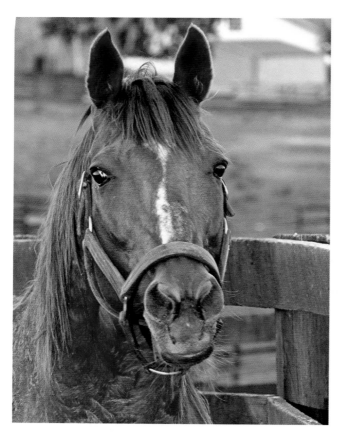

Left: Tinners Way was the last great son of Secretariat and a two-time winner of the Pacific Classic. Sadly, he died on July 5, 2017. *Courtesy of Joyce Patci.*

Below: Fabulous Strike's biggest win was the 2007 Grade 1 Vosburgh Stakes. He is Hall of Fame jockey Ramon Dominguez's favorite racehorse. *Courtesy of author.*

Archie's Echo is one of those sweet, loveable hard-knockers to call Old Friends home.
Courtesy of author.

Slamming is the favorite of Lorita Lindemann, a very good friend of Michael Blowen.
Courtesy of author.

Bonapaw took the Richards brothers on the "Ride of a Lifetime." His biggest win was in the 2002 Grade 1 Vosburgh Stakes. He died on July 7, 2017, after a nice retirement at Old Friends. *Courtesy of author.*

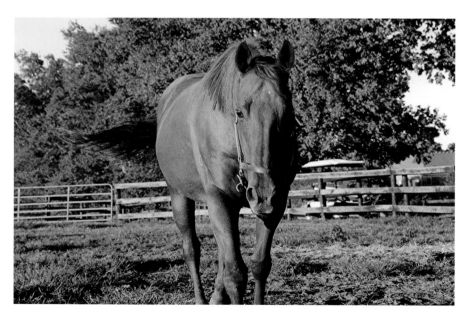

Bint Marscay is an Australian champion mare and a favorite of Old Friends volunteer (and superb photographer) Laura Battles. *Courtesy of Laura Battles.*

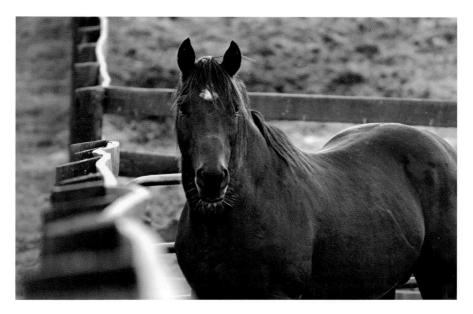

Leave Seattle, a favorite of Old Friends supporter Don Veronneau, poses for a portrait on a nice day at Old Friends. *Courtesy of author.*

Wallenda watches his little friend Sally romp around outside his paddock. The little dog is the companion of volunteer Wade Houston. *Courtesy of author.*

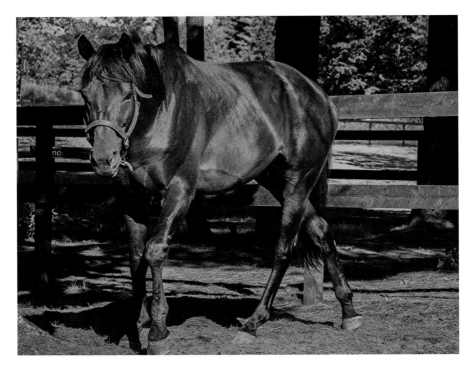

King Congie had an interesting road to Old Friends. From stakes winner to the auction block, he's now at Cabin Creek thanks to Terry Finley and West Point Thoroughbreds. *Courtesy of Connie Bush.*

Zippy Chippy, *left*, the losingest horse in racing history, bonded almost immediately with Red Down South at Cabin Creek. *Courtesy of author.*

Commentator, who was originally at Old Friends in Kentucky, moved to Cabin Creek to be closer to his New York fans. *Courtesy of author.*

Thunder Rumble, the original stallion at Cabin Creek, loved to run around his paddock at Cabin Creek. *Courtesy of Connie Bush.*

Thornfield, the 1999 Canadian Horse of the Year, now calls Old Friends at Kentucky Downs home. *Courtesy of author.*

Rumor Has It, one of the sweetest horses at Old Friends, is another retiree at Old Friends at Kentucky Downs. *Courtesy of author.*

On a snowy winter morning, January 23, 2016, the farm's medical barn caught fire, but Alphabet Soup was unfazed by all the commotion. *Courtesy of Diane White.*

Shortly after the fire, funds were raised thanks to Old Friends supporters and Blue Horse Charities through Fasig-Tipton, and a new barn was built and ready for use. *Courtesy of author.*

A beautiful sunrise greets a new day at Old Friends. *Courtesy of Carole Oates.*

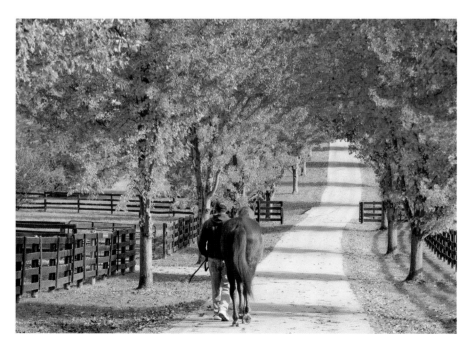

Old Friends volunteer John Bradley walks his favorite horse, Mixed Pleasure, out to his paddock for the last time. The next day, the horse was euthanized. *Courtesy of Kurt Lemke.*

When the twins approached the marketing person at Children's Hospital and told them what they planned to do, the person just said, "Yeah," as he had heard that story before.

But according to James Jr., "When Bonapaw won a race, they sent a check. A couple weeks later, they win a race, the check goes. A few weeks later, they win, a check goes....Well, needless to say, they wrote checks for almost $400,000 to the hospital."[81]

The hospital soon realized that the Richards brothers weren't kidding. "So, they came down to our office and they gave [the twins] some plaques from the Children's Hospital from the kids," said James Jr. "In the end, after the twins had passed away, they named the cancer ward after our dads."[82]

————

Bonapaw continued winning over the next two years, and in March 2002, the brothers decided to take him to Dubai and run him in the Dubai Golden Shaheen (UAE-1). But it just wasn't his day, and he finished sixth.

Soon after that race, James was diagnosed with cancer, which came just before the Vosburgh Stakes. However, James wanted to see Bonapaw run in the Vosburgh because if his horse won, it would be the first Grade 1 win of his career. So, against doctor's orders, James traveled to New York for the race but then got sick and had to go to the hospital there.

According to James Jr., though, "[My dad] kept telling the nurse and the doctor, 'You all have got to let me out of here. Either you're going to let me out or I'm going to walk out of here. You all don't realize that my horse is running today and we're going to win the race and I've got to be there.'"[83]

Reluctantly, they let him out, and he went to watch the race.

————

James and Dennis Richards were in the stands cheering Bonapaw as he ran down the stretch in the Vosburgh Stakes. On this day, Bonapaw was not to be denied his first Grade 1 win. He was in command of the seven-furlong race from the start and, with Melancon aboard, crossed the finish line a 2-1/2-length winner. Bonapaw ran the race in 1:22.34.

In the winner's circle after the race, everyone celebrated Bonapaw's win. However, it would be the last big win of his career.[84]

Upon returning home, James's health deteriorated quickly, and six months after their Vosburgh victory, he lost his battle with cancer and died on March 26, 2003.

After that, Bonapaw was never the same, according to James Jr. It was as if he knew James, the longtime friend he met at Keeneland, was gone. Sure, Dennis was James's twin, but it seemed that Bonapaw knew the difference between the two brothers.

After James died, "We tried to make him [Bonapaw] run. We tried," said James Jr. "But he wouldn't. He just wouldn't."[85]

Still, they did try to run him. Nine times in fact—six times in 2003, twice in 2004 and once in 2005. But other than a win in an allowance race at Keeneland on October 10, 2003, Bonapaw had lost interest in racing, and so they retired him, turned him out on their farm and just let him be a horse.

Bonapaw, who was foaled in Kentucky on April 13, 1996, by Sabona-Pawlova, by Nijinsky (Can.), finished his career with eighteen wins (twelve in stakes races), seven seconds, four thirds and $1,158,752 in earnings in forty-nine starts.[86]

A few years later, on January 21, 2009, Dennis passed away after his own battle with cancer. Before their fathers passed away, James Jr. and Dennis Jr. made a promise that they would look after Bonapaw and make sure he had a good life. However, as the bills to care for him mounted, they decided they needed to find a place to retire him and keep their word to their fathers.

In talking to people, James learned about Old Friends. He researched it and liked what people had to say about it, but he had no idea what to say or ask the owner, Michael Blowen.

After learning more about Old Friends, James Jr. called Michael one day and told him the story of Bonapaw and the Richards twins, and Michael said, "I know that horse and I know the twins." It turned out Michael had met James and Dennis at a race in New York and had seen Bonapaw run in a race.

James Jr. said, "I need a place to put [Bonapaw]. He's retired, and he can't run no more. My cousin and I really don't know what to do. Can you help?"

Michael said, "How soon can you have the horse ready to go?"

James replied, "He's ready to go now."[87]

Michael made the arrangements, and in February 2009, Bonapaw arrived at Old Friends. According to Michael, besides being a beautiful

and friendly horse that fans adore meeting, Bonapaw is important to Old Friends for a few reasons.

"Bonapaw fulfills a very important niche at Old Friends," said Michael:

> He's one of those horses that was purchased cheap, was a hard worker, and he won a lot of great races....He's a poster boy for people going to the sale and not worrying about whether they're going to spend $2 or $3 million on the first day. But on the last day, with just a couple of horses left, you never know who's going to be there....The other thing [about Bonapaw] is it really goes to my thought that the difference between these great racehorses isn't conformation or breeding or training or anything else. It's intelligence, and Bonapaw is very smart. He knew how to be a racehorse.[88]

On July 7, 2017, Bonapaw was euthanized due to complications caused by the neurological disease EPM. While it was sad to lose the sweet gelding, the thought of him reuniting with the Richards brothers in heaven brought a smile to everyone on the farm.

Chapter 13

LITTLE MIKE

*A*s Michael Blowen and many volunteers at Old Friends will tell you, every day at the farm is special. But every once in a while there is a day that is extraordinarily special. According to Michael, there is a story about the day Little Mike arrived at Old Friends that made it one of those extraordinary days. But first, here's the story of Little Mike's race career.

––––––––––

Little Mike, who is by Spanish Steps-Hay Jude, by Wavering Monarch, was foaled on May 24, 2007, in Florida. He was bred and owned by Carlo E. Vaccarezza and Priscilla Vaccarezza. Carlo also trained him.

The best year of Little Mike's career came in 2012 at age five, when he won the Arlington Millions Stakes (G1) at Arlington Park, the Woodford Reserve Stakes (G1) at Churchill Downs, the Florida Sunshine Million Turf Stakes at Gulfstream Park and, in his biggest career win, the Breeders' Cup Turf (G1) at Santa Anita.

Then, in an interesting tie to Old Friends, in 2014 at age seven he won the Flying Pidgeon Stakes. Flying Pidgeon had been a retiree at Old Friends. He died on December 5, 2008.

In 2015, Little Mike suffered an injury and was sidelined for twenty-six months. Then, on July 10, 2016, he returned to Gulfstream Park in Hallandale, Florida, and finished fifth in an allowance race. After that race, Carlo decided to retire him.

All told, Little Mike won fourteen times, finished second twice, third once and earned $3,543,392 in twenty-nine career starts.[89]

According to Michael, Carlo had already talked with him about retiring Little Mike to Old Friends someday, and he called right after his final race. "Within twenty minutes of that race, Carlo called and asked if Old Friends had a spot for Little Mike," said Michael. He said yes, and the wheels were set in motion to bring Little Mike to Old Friends.[90]

That brings us back to the day Little Mike arrived at Old Friends.

———

Early Friday morning, July 29, 2016, Michael began the day with his normal routine. He visited Silver Charm and then headed over to see Little Silver Charm. As he got closer to Little Silver Charm's paddock, he noticed someone walking in the barn. Michael went over and introduced himself, and the man turned out to be Carlo Vaccarezza. He had flown all night just to be at Old Friends so he could walk his horse off the van and into his retirement. That's how much Little Mike meant to him.

A short time later, the van carrying Little Mike arrived. Carlo climbed in and, shortly after, came down the ramp leading Little Mike into his new home at Old Friends.

Carlo gave Little Mike a pat and smiled. They put him into the round pen next to the barn. Little Mike rolled in the dirt, got up, shook off the dirt and settled right in. Carlo then said goodbye to his horse and to Michael and headed home to Florida.[91]

For Michael, the fact that Carlo loved his horse so much that he came to Kentucky to lead him off the truck at Old Friends just gave him the chills and made that day one of those extraordinary days at Old Friends.

Chapter 14

KING CONGIE

On September 2, 2016, King Congie, a graded stakes–winning Thoroughbred stallion, found himself standing at an auction house, scared, with a cut above his eye and blood falling from his ankle, while surrounded by other scared horses. His fate, at that moment, was unknown. If he was lucky, maybe someone would adopt him and give him a nice home and a happy life. If he was unlucky, he would be purchased by a kill buyer and sent to a slaughterhouse in Mexico or Canada.[92]

While the United States no longer allows horse slaughter, and supposedly does not allow the transport of horses to Canada or Mexico for that purpose, there is, sadly, a booming business in those two countries for the sale of horse meat.

So, there stood King Congie, an eight-year-old Thoroughbred in the prime of his life, winner of $243,740 in eleven career races, silently awaiting his fate.

———

King Congie, who is by Badge of Silver-Wise Ending, by End Sweep, was foaled in Kentucky on March 2, 2008.

As a two-year-old in 2010, he won one race in three starts. In 2011, as a three-year-old, he had his best year, winning the Tropical Park Derby (G3) at Churchill Downs. He also placed in some other stakes races that year. In all, he won $209,900 that year.

King Congie was saved at an auction and now lives happily at Old Friends at Cabin Creek in New York. *Courtesy of Connie Bush.*

As a four-year-old in 2012, he ran only once but did not place and was retired after suffering an injury. Upon retirement, King Congie had two wins, one second, three thirds and $243,740 in earnings in eleven career starts.[93] Since he was ridgling, his owner, West Point Thoroughbreds, looked for a new home for him.[94]

Now, West Point Thoroughbreds is a leader in the aftercare of Thoroughbreds, and it cares about all of its horses. It had sent King Congie to a "friend of a reputable farm owner in Saratoga" in 2012. Thinking he now had a nice home, West Point lost track of him. What it didn't know was the owner of the farm had financial problems and had sent King Congie to another owner.[95]

West Point Thoroughbreds had named King Congie after a former employee, Congie DeVito, who passed away in February 2011 at age thirty-five from complications from osteogenesis imperfecta. In his honor, West Point started the Congie Black and Gold Fund for the purpose of providing

"for the rehoming, retraining, shipping and daily care of former West Point Runners. Beginning in 2012, financials for each new partnership formed by West Point included a $1,000 donation to the fund; $10 per start per horse is drawn from the partnership to be placed in a fund for that horse's future with West Point matching the amount."[96]

So, while West Point Thoroughbreds thought it had found King Congie a good home, it didn't work out that way. That is why, four years later, the Thoroughbred found himself standing at the auction house.

Luckily for the beautiful Thoroughbred, also at the auction house that day was Dawn Robin Petrlik, owner of Rosemary Acres Horse Rescue in South Kortright, New Jersey. She had come to the auction looking for two specific horses a friend had told her about. She never found those horses, but she did spot King Congie.[97]

While someone else won the auction for him for $250, she found the person later that day in the parking lot trying to sell him. After some negotiating, she was able to purchase him for $100. King Congie had been rescued. "This was the closest save we've ever made," said Dawn at the time. "If we had not been there, his [the person who bought him] next move would have been to offer the horse to the kill dealers who were still in the parking lot."[98]

With King Congie now safe, Dawn began to try and track down his former owners. The person who purchased him also had the horse's papers, and after some online research, she discovered he was owned by West Point Thoroughbreds. She contacted the organization and related the story, and the wheels began to turn to find him a home.[99]

The owners of West Point Thoroughbreds, Terry and Debbie Finley, officially adopted King Congie and committed themselves to supporting his aftercare.

The first thought was to send King Congie to a rehab facility in Maryland. But then Erin Birkenhauer, the media representative for West Point Thoroughbreds and the first person Dawn spoke to at the farm, mentioned Old Friends at Cabin Creek as a possible place to send King Congie for his retirement. Old Friends at Cabin Creek: The Bobby Frankel Division was Old Friends' first satellite farm, which opened in 2009.[100]

West Point called Old Friends and related the story, and everyone agreed that Old Friends would be a perfect home for King Congie. One week after the call to Old Friends, Dawn drove down the driveway to the barn at Cabin Creek, while King Congie looked out the trailer window at his new home. Waiting to greet their new retiree were JoAnn Pepper, owner of Old Friends at Cabin Creek, with her husband, Mark, as well as some Old

Friends volunteers. Soon after the van arrived, JoAnn led King Congie out of the van and into a stall in the barn.

As he was being led into the barn, "in a nearby paddock, Commentator, winner of two Whitney Stakes races, neighed out a greeting as King Congie walked into the stable with a stately dignity befitting his grace and stature. He responded with a fiercely defiant trumpeting. Perhaps Congie's dignity was borne of breeding, or perhaps it was an understanding that, after going through so much, he was finally in a place he could safely call home."[101]

Today, King Congie enjoys his days grazing, playing and napping. That is, until a tour comes by. Then he goes right to his fence to enjoy all the attention he can get from the visitors. This is definitely another story with a happy ending.

Chapter 15

THORNFIELD

*A*t one time in 2013 and 2014, about thirty to forty Old Friends horses were being boarded at Nuckols Farm in Midway, Kentucky. One of them was a sweet chestnut gelding named Thornfield, the 1999 Canadian Horse of the Year.

What is interesting about Thornfield was watching how his confidence grew at Old Friends. When he first arrived, he was friendly and would greet visitors when they came to his fence. Then, when he and the other horses were moved to Nuckols Farm, he became shy. If you walked toward him, he'd turn and walk away from you.

When the horses at Nuckols were moved back to the main farm, Thornfield, while still a little shy, slowly broke out of his shell. He wouldn't walk away when someone approached. He'd watch the other horses walk over to the fence to greet them and get some carrots, and then he'd cautiously move to the fence and accept some carrots as well. His confidence and friendliness were growing.

———

Thornfield, who is by Sky Classic (Can.)-Alexandrina (Can.), by Conquistador Cielo, was foaled in Canada on March 15, 1994. His biggest wins came in 1999, when he won the Canadian International Stakes (CAN-G1) and the Niagara BCH (CAN-G2), both at Woodbine.

Thanks to those wins, as well as a third-place finish in the Sky Classic Stakes at Woodbine, which was named after his sire, Thornfield was awarded

the Sovereign Award as 1999 Canadian Horse of the Year and Canadian Champion Male Turf Horse.

It is interesting to note that Thornfield "holds the honor of being the only Canadian Horse of the Year to be sired by a Canadian Horse of the Year."[102]

Upon retiring, Thornfield had six wins, one second, three thirds and $1,206,074 in earnings in nineteen starts.[103]

———

Today, Thornfield lives at the new Old Friends annex at Kentucky Downs. He was one of the original horses moved there when the annex opened. Now, when visitors come to the fence, he races over to greet them and get some carrots. He even lets visitors pet him and seems to really enjoy all the attention. He has finally come into his own at Old Friends.

———

Thornfield is not the only Canadian Horse of the Year to be retired to Old Friends. In 2009, Benburb, the 1992 Canadian Horse of the Year, arrived at the main farm to enjoy his retirement.[104]

Benburb's name came from the Gaelic *beann bhorb*, which means "defiant cliff." The castled village Benburb is in County Tyrone, Ireland.[105]

Foaled in Canada on February 9, 1989, Benburb had his best season as a three-year-old in 1992, when he scored an upset win in the Prince of Wales Stakes over Queen's Plate winner Alydeed on a muddy track at Fort Erie Race Track, as well as another upset win in the Molson Export Million Stakes (CAN-GR2) over U.S. Horse of the Year A.P. Indy, who finished fifth; Alydeed, who finished sixth; and Grade 1 winner Technology, who finished fourth.[106]

With those wins, Benburb, a stunningly beautiful gray Thoroughbred by Dr. Carter-Rosedon, by Vice Regent, earned the Sovereign Award as 1992 Canadian Horse of the Year and Canadian Champion 3-Year-Old Male Horse.[107]

As a four-year-old, Benburb won the Durham Cup (CAN-G2) at Woodbine and was retired later that year. In all, Benburb won seven times, finished second two times, third four times and earned $1,159,904 in twenty-two career starts.[108]

Sadly, Benburb died at age twenty-three due to complications from melanomas at Hagyard Equine Medical Institute in Lexington on

Benburb, the 1992 Canadian Horse of the Year, also called Old Friends home at one time. *Courtesy of author.*

August 1, 2012.[109] "We were really blessed to have retired Benburb," said Michael Blowen in a press release. "He was the kindest of them all.... When his time came, we returned his kindness. And he was grateful. He is irreplaceable."[110]

Chapter 16

GELDINGS AND MARES

Currently, Old Friends has more than 160 horses spread across all of its farms. From the main farm in Georgetown to Old Friends at Cabin Creek, Old Friends at Kentucky Downs and a few leased farms near the main farm in Kentucky, there are stallions, geldings and mares enjoying happy retirements. While it would be wonderful to share the stories of every one of them, unfortunately there is only room for a few. Here are some of their stories.

ARCHIE'S ECHO
BY PALACE MUSIC-CHICSTAR, BY STAR DE NASKRA

Archie's Echo was foaled in Kentucky on May 8, 1989. He ran mostly at Rockingham Park and Suffolk Downs. In his career, he won seven races, finished second six times, third four times and earned $32,324 in forty career starts.[111]

The loveable chestnut is one of those hard-knocking workhorses that make up the majority of Thoroughbred racing. During his career, he gave everything he had in every race he ran, and all he asked in return was a nice place to live, food and a little love.

Unfortunately, it didn't happen. Somehow, in 2015, at age twenty-six, with a bad eye and underweight, he found himself at the New Holland auction house. Luckily for the old war horse, he had a savior that day, as Sam Elliott

of Parx Racing pulled out his credit card before he even saw the gelding's photo. He handed it to Danielle Montgomery of the Parx retirement charity Turning for Home and simply said, "Pull him."[112]

With those words, Archie's Echo's life had been spared, and he was on the road to happier days at Old Friends.

It did take a number of people to put a plan together to get him there, including Michael's longtime friend and trainer from Suffolk Downs Lorita Lindemann. She remembered the horse as one of the first ones she took care of at the track. As soon as she heard about Archie, she called Michael to ask if he had room at Old Friends, and Michael said yes.

Soon, after a little rehabilitation to put some weight on him, Archie arrived at Old Friends, where he now enjoys a peaceful retirement.

SAY FLORIDA SANDY
BY PERSONAL FLAT-LOLLI LUCKA LOLLI, BY SWEET CANDY (VEN.)

Say Florida Sandy was foaled in New York on March 29, 1994. The biggest wins for the dark-brown/brown stallion were the Philadelphia Park Breeders' Cup Handicap (G3) at Philadelphia Park, the Bold Ruler Handicap (G3) at Aqueduct and the True North Handicap at Belmont Park—all three in 2001. He also won the Gravesen Handicap (G3) at Aqueduct two times in 1998 and 2000.

It was 2001 when Say Florida Sandy won three grades stakes races and earned his reward. "Say Florida Sandy has his share of New York–bred championships, but had never won the state's Horse of the Year. But his 2001 campaign as a 7-year-old was too good for voters to overlook, so Say Florida Sandy earned his much-deserved Horse of the Year title when the winners for New York–bred championships were announced March 26 in Albany, New York."[113]

Say Florida Sandy also became the all-time leading New York–bred in earnings when he finished second in the Hudson Handicap.[114] Upon retirement, Say Florida Sandy had thirty-three wins, seventeen seconds and twelve thirds and earned $2,085,408 in ninety-eight career starts.[115]

He entered stud in 2004 at Buckridge Farm and stood there for ten years. In 2015, he was relocated to Old Friends and currently lives at Hurstland Farm in Midway, which was one of the original locations of Old Friends prior to moving to the Georgetown facility.[116]

LION HUNTER
BY LION HEART-TEERRII SUE, BY TURKOMAN

Lion Hunter was foaled on May 4, 2009, in Kentucky. He never raced and was retired to Old Friends to enjoy his days grazing, sleeping and playing with his paddock pals. He also became a favorite of Carole Oates, an assistant farm manager. She explained why:

> *I've worked with many horses over the years, and only a few have really touched my soul. Lion Hunter is one of them. He was a gangly young horse in the back forty of the farm. Very shy and skeptical about me coming into his paddock. Not very attractive; just a plain bay with a black mane and tail.*
>
> *Something about his eye drew me in. So, I decided to make him my project. Every day I would try to pet him and rub on him. Eventually, he came around and decided I wasn't so bad.*
>
> *Now, he is in the front of the farm, and he has lost that gangly look. He blossomed into a beautiful seventeen-hand, handsome devil with a long*

Old Friends assistant farm manager Carole Oates enjoys a moment with her favorite horse, Lion Hunter. *Courtesy of author.*

forelock and a huge personality. When I enter his paddock, he will come right over to me to be scratched and loved on. The only problem with that is I have nine other horses in the field to check, and he won't let me go near anybody else. He herds me around, begging for all the attention and chasing everyone else away.

I feel a close connection to this horse and am amazed how horses pick their people. I am honored that he has picked me.[117]

MIKETHESPIKE
BY ANET (CAN.)-BLACK TIE ROYALTY, BY BLACK TIE AFFAIR

MiketheSpike was foaled in Florida on March 11, 2000. A beautiful gray gelding, "Mikey," as he is called, raced 126 times, won 12 times, finished second 11 times, third 17 times and earned $85,301.[118]

It was Mikey's tie to Black Tie Affair, a former Old Friends retiree, and his workmanlike race career that caught the eye of Old Friends volunteer Vivian Morrison, who worked tirelessly to bring him to Old Friends.

MiketheSpike was donated to Old Friends by Vivian Morrison and her fellow Team Ivytree partner, Bea Snyder, both volunteers at the farm. *Courtesy of author.*

Along with her friend Bea Synder, they had created Team Ivytree, in which they collected money for the Appygolucky Memorial Fund to help horses like Appygolucky get a well-deserved retirement. Appygolucky, whom Michael Blowen nicknamed "the Claiming King of Beulah Park," was the first horse Vivian had retired to Old Friends. He died on October 5, 2009.

So, when "Mikey" was injured in his final race at Pinnacle on June 27, 2010, he became the first recipient of the fund. Viv explained:

> *After we lost Appy, I decided that I could not sit idle with grief. I approached Michael with a plea. Would he give his blessing to my mission? To save one hard-knocker in Appy's name? Despite lack of space, lack of funds, somehow I had to do this. Michael said, "We'll find a way," and the Appygolucky project was born. I couldn't save my friend, but by God, I wouldn't let his death be in vain or his name forgotten. He was the "King" after all…and I made a promise.*

Well, Viv and Bea, along with help from Gail Hirt, who boarded Mikey while he recovered from his injury, did keep their promise, and the sweet gray gelding arrived at Old Friends in December 2011.[119]

Slamming
by Claim-A Smash, by Star De Naskra

Slamming was foaled in Kentucky on March 21, 1993, and became a favorite of Michael's friend Lorita Lindemann.

In his career, which ran for eight years between 1995 and 2002, he raced eighty times, won twenty times, finished second sixteen times, third twelve times and earned $206,019. Seven of those wins came in stakes races.[120] Upon retirement, he stood at stud for a few years before coming to Old Friends.

Lorita explained why he is one of her favorites:

> *Back in the summer of June 2002 at Rockingham Park, I had been watching this horse and wanting to claim him with David C. George, an owner that I had one horse with at the time. He gave me a shot and we claimed him, and it was just amazing from there.*

Slamming ran for us from that point on between Rockingham Park and Suffolk Downs, always earning us a check. He was a poor man's horse.

Our first start of the claim was one to remember, as he won by twelve lengths and his stable mate finished second. That horse was Michael's horse, Summer Attraction. It was quite exciting.

Slamming won six races for us and almost always picked up a check. He was the breadwinner by far.

His career ended in May 2002 after he finished third and suffered a sesamoid that would end his racing days. That's when I knew I had to do the right thing and keep him and rehab him. I not only owed it to him, but I loved him and believe we had something special.

I had trained, retired, rehomed hundreds of horses, but I was not letting him go. The dark bay gelding now calls Old Friends home, along with his fellow stable mates Summer Attraction; Duke Ora, who is owned by David C. George; and the late Invigorate, another of Michael's horses.[121]

FABULOUS STRIKE
BY SMART STRIKE-FABULOUS FIND, BY LOST CODE

Fabulous Strike was foaled in Pennsylvania on April 4, 2003, and had a "fabulous" career. In his career, he raced twenty-eight times between 2005 and 2011 and won fifteen times, was second five times, third one time and earned $1,447,804.

Twelve of his wins were stakes races and five of them graded stakes: the Vosburgh Stakes (G1) at Belmont and the Aristides Breeders' Cup Stakes (G3) at Churchill Downs, both in 2007; the Gravesend Handicap (G3) at Aqueduct in 2008; and the True North Handicap (G2) at Belmont and the Alfred G. Vanderbilt Handicap (G2) at Saratoga, both in 2009.[122]

Fabulous Strike's racing career ended in 2011, and he was donated to Old Friends to enjoy his retirement.

SANTONA
BY WINNING-SYRACUSE (CHI.), BY SHARP-EYED QUILLO (CAN.)

Santona came to Old Friends by way of Chile, where she was the 1997 Champion Grass Mare.

Santona, the 1997 Champion Grass Mare in Brazil, is queen of the mare's paddock. *Courtesy of author.*

She was foaled in Chile on October 7, 1994, and raced in 1997 and 1998. Her win in the Las Oaks (Chi.-G1) and her second place finish in the PR Lisimaco Jaraquemada that year helped her earn her championship status. She retired from racing with four wins, two seconds, four thirds and $43,438 in earnings.[123]

Today, Santona lives in the mare's paddock on Old Friends' Back 40, and she is, without question, the queen of the paddock. If you want to visit any mare in that paddock, you first must say hello to Santona and give her some scratches and carrots. She is the gate keeper. However, it's not because she's being a diva or mean-spirited; it is most probably because she is lonely, as the other mares seem to get all the attention. She just wants a little love and attention, that's all. Give her that and she's happy and your new best friend.

BINT MARSCAY
BY MARSCAY (AUS.)-EAU DETOILE (NZ.), BY SIR TRISTRAM (IRE.)

Bint Marscay had a long road to Old Friends. Foaled in Australia in 1990, the chestnut beauty won a number of races between 1993 and 1994.

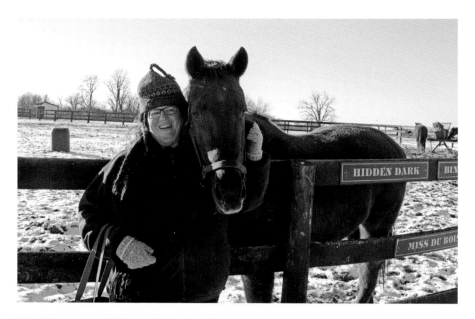

Bint Marscay, a multiple graded-stakes winner in Australia, is a favorite of Old Friends volunteer Laura Battles. *Courtesy of Kurt Lemke.*

In 1993, as a two-year-old, she won the Tooheys Golden Slipper Stakes (AUS-G1), the Magic Night Stakes (AUS-G2) and the Kindergarten Stakes. For her efforts, she was named Champion 2-Year-Old Filly in Australia. In 1994, she also won another graded stakes, the Chirnside Stakes (AUS-G2).

At retirement, she had four wins, two seconds, two thirds and $1,505,838 (Aus. money) in earnings in ten career starts.[124]

Today, Bint Marscay is happily retired at Old Friends and is a favorite of Old Friends volunteer and photographer Laura Battles. Here Laura shares her relationship with "Binty":

> *I have always been a fan of international racing. When I heard we were getting the pensioned Australian champion Bint Marscay, I made it a point to see her out in the big mares herd, but that was about it for a couple of years. Fast-forward to the spring of 2016 and that little Australian champion was now the paddock mate of a favorite of mine, Hidden Lake. It became the "Paddock of Champions."*
>
> *On my visits to that paddock, I started grooming the orange mare, and she seemed to like the attention and would stand all day. Binty also loves*

to eat. *I started bringing her carrots to finish off grooming time, and she loved it.*

As it got warmer, both of the girls started getting baths to cool off in the hot weather. Binty knew to wait for the diva to get her bath first and would patiently wait her turn. One night, Hidden Lake decided she did not need a bath, so I led Binty over and started hosing her down. By that point, Hidden Lake had come over and was standing in the middle of the paddock with a "What the…?" look on her face trying to figure out how come Binty was getting a bath and she was not.

Binty loves her carrots that I let her bite off whole. I started digging through the carrots at the store to find skinny carrots that she could bite. Well, actually, she holds the carrot with her teeth while I snap it off for her. It's a team effort. She is such a well-mannered mare. She will search me for carrots running her nose up one side of me and down the other, but she has never tried to bite me.

She is a very itchy mare in the summer and loves to have her belly scratched. She will position herself exactly where she wants to be scratched, and if I try to scratch somewhere else, she just moves back to where she wants to be scratched. My arms and neck were getting so tired from scratching that I bought one of those wooden back scratchers that look like a human hand and started using it on her.

As the summer progressed and I fell more in love with Binty, I started researching her career. I discovered that I actually saw her last race when I was in Australia in 1994. What a small world. I found the race card with her name in it and a photo I snapped of the race where you can just see her head at the edge.

These days, Binty knows that we groom first and eat carrots later. Unless she really wants carrots, then we might do carrots first sometimes. [125]

Chapter 17

GONE BUT NOT FORGOTTEN

MAIN FARM

One of the things that tourists seem to enjoy at Old Friends is hearing the stories of the horses given by the tour guides. Every horse has a story, whether it is the horse's racing accomplishments or a story about how a horse persevered in its life and finally found a loving home at the farm.

One of the hardest parts for the people who volunteer at Old Friends is that they become attached to one or more of the horses. So, when a horse dies, someone on the farm grieves for the loss.

That's when things seem to switch around a little. When the horse is alive, it is their stories that people love to hear. But when a horse dies, then it's one of the people who loved them whose stories people enjoy hearing. Here are a few of those stories.

GET LUCKY
BY MR. PROSPECTOR-DANCE NUMBER, BY NORTHERN DANCER

AND

HALO AMERICA
BY QAQUOIT-AMERIANGEL, BY HALO

Get Lucky and Halo America arrived at Old Friends together in 2014 and lived mostly at Nuckols Farm in Midway, Kentucky. When they arrived, Get Lucky was twenty-six and Halo America was twenty-four.

Get Lucky was foaled in Kentucky on April 6, 1988. She had the biggest win of her career in 1992 in the Affectionately Handicap (G3) at Aqueduct. Upon retiring, she had five wins, four seconds, one third and $157,760 in earnings in eleven career starts.[126]

Halo America was foaled in Florida on March 29, 1990. Her biggest career win came in 1997, when at age seven she won the Apple Blossom Handicap (G1) at Oaklawn Park. Upon retirement, she had fifteen wins, eight seconds and two thirds and $1,460,992 in earnings in forty career starts.[127]

Both horses were beautiful to watch as they grazed side by side. But for some reason, while he really liked both horses, Charles Nuckols III fell in love with Get Lucky. He explained:

When Michael sent Get Lucky and Halo America here, both did have issues. We deal with a lot of horses and a lot of problems, from babies to stallions. So, when she [Get Lucky] got off the van and I got over there, I was about ten minutes late—somebody had already called the veterinarian to come over to put her down. To euthanize her. We're standing in front of barn 11, and she looks pretty good to me.

Get Lucky, *right,* and Halo America enjoyed most of their retirement at Old Friends at Nuckols Farm in Midway, Kentucky. *Courtesy of author.*

I said, "Well, walk her up and back." She was a little gimpy, and no big deal, even though she did have a problem [with] some ankle issues. So, the doctor went to the back of his truck and came out with a syringe, and I asked, "What are you going to do?" And he said, "Well, we're going to euthanize her right now." And I said, "Not on this farm."

According to Charles, he believes the doctor "called Michael [Blowen] to tell him what was going on, and Michael told him to leave the horse alone—to do whatever Nucks said to do with her."[128] So, Get Lucky got to enjoy fourteen more good months of living with Halo America at Old Friends. Charles continued the story:

You could tell she was a fighter. She was just laid back and just like a big kitty cat. She wouldn't get five feet away from Halo. Even though Halo was kind of the boss. She was always in front grazing, and Lucky was on one side or the other.

We knew what the outcome was going to be with both of them with their ages and whatnot. But they were never in pain, and we made sure of that. We treated them just like we treated a mare and a foal or a yearling. They both had their own stalls and were put up and fed. You could tell if they cleaned up their food they're okay; if they drank a bucket of water they're okay. If they didn't, something was a little "ouchy" on them, and we'd take their temperatures and take care of them. Help them get through a cold day. That's really about it.[129]

Their stall setup was one of the fun things Charles remembers about the two. At first, they were in stalls next to each other. But that had to change. With a smile, he explained:

Well, that was a problem. We didn't realize in the beginning when they were in stalls beside each other....They were very nervous not being able to see each other. So, we ended up putting Get Lucky straight across from Halo, so Lucky and Halo could view each other. And that stopped all the nickering.[130]

Get Lucky died on March 8, 2015, and it was a hard loss for Charles. Even to this day, he chokes up a little when he talks about her. Halo America stayed at Nuckols Farm a little longer and then moved to Old

Friends main farm in Georgetown. She died on July 7, 2016, due to declining health.

Leave Seattle
by Seattle Slew-Leave Me Alone, by Northern Dancer

Leave Seattle was foaled in Kentucky on April 15, 1988. He raced only three times and never placed.

Once retired, he stood at stud in Massachusetts for a time but then somehow ended up in a slaughter auction, where he was rescued. Once he arrived, Don Veronneau, an Old Friends supporter, became his best friend and frequent visitor. Don shared his memories of his favorite horse:

I first met Leave Seattle on June 22, 2006, while on a tour of Old Friends. He struck me as a special horse then, but he seemed to me on that day a sad horse. When I returned home, I could not get him out of my thoughts or out of my heart. I decided to sponsor him and do everything I could to improve his life.

Each time I visited Kentucky, which I did often after meeting Leave Seattle, I did so for the specific purpose of visiting with him and spending as much time as I possibly could with him, bringing him carrots and just being with him. I was never ever able to surprise him by my visits because [somehow] he always knew when I was arriving at the farm.

During one of these earlier times, it seemed as if Leave Seattle always wanted to bite, but what he really wanted to do was just play using a sleeve of a sweatshirt I was wearing. I finally understood what he was trying to relay to me about this game he wanted to play. From then on, Leave Seattle and I played tug-of-war games with any long-sleeve clothing I was wearing.

On one particularly warm April day in 2010, I just wore a T-shirt and went to visit, and Leave Seattle wanted to play our game again. But since he realized that I had nothing we could play with, he put his head down in his paddock and brought up a huge clump of grass, which he held out for me to grab. Since it was a game, he wouldn't let me touch it. Over and over, he would hold it up for me to grab, and he would pull it away. This continued for ten to fifteen minutes until the clump fell apart, and the game concluded. Leave Seattle's finding a substitute with which to play demonstrated to me and a witness his intelligence and resourcefulness.[131]

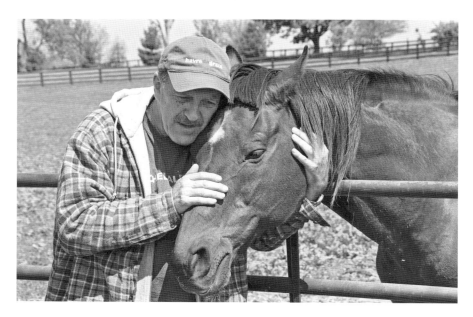

Leave Seattle and his best pal, Don Veronneau, an Old Friends supporter, share a touching moment together. *Courtesy of Beth Tashery Shannon.*

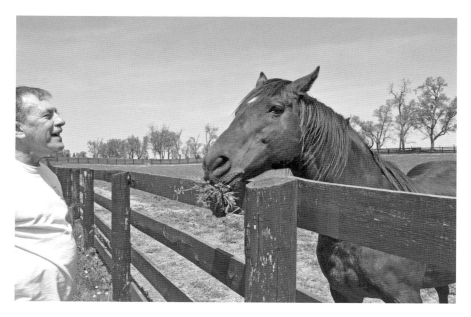

Leave Seattle and Don Veronneau play tug-of-war with a clump of grass. *Courtesy of Beth Tashery Shannon.*

Sadly, on May 18, 2012, Leave Seattle was euthanized due to the infirmities of old age. It was something Don knew might be coming, but it still hurt deeply:

> *In 2012, I had this premonition that Leave Seattle and I would not see one another again, so I spent as much time with him on a daily basis as I could. In the four weeks I spent in Kentucky, I often would go to visit him each morning and every late afternoon, bringing him carrots and playing tug-of-war if he wanted to do so. Each time, I remained with him for several hours.*
>
> *Although I have been involved with other horses, including my own, I have never had the experience I had with Leave Seattle. I am so grateful that he chose me to be his friend, and our relationship was a unique, mystical bond between two different species. He was kind, intelligent, friendly, playful and shared his love with those who appreciated and loved him. Kentucky can never be the same for me without Leave Seattle, and I will miss him forever until we meet again.*[132]

Mixed Pleasure
by Sucha Pleasure-Sea I'm Lucky, by Windy Sea

Mixed Pleasure was foaled in California on May 20, 1985. At retirement, he had five wins, six seconds and one third and earnings of $140,175 in twenty-two career starts. His two biggest wins came in 1987, when he won two restricted stakes races: the Ford Juvenile Stakes at Bay Meadows and the Kindergarten Stakes at Golden Gates Park.[133]

According to the Old Friends website, "Mixed Pleasure, who was a great-great grandson of Seabiscuit, had been pensioned at Old Friends since 2012 after being saved by Charlotte Farmer and the nationwide advocacy group Equi-Army-NDO.com. The stallion had stood at Grand Trine Farm in Molalla, Oregon, and was one of 14 horses seized by the rescue group when former owners attempted to place them for sale in an auction."[134]

Upon Mixed Pleasure's arrival at Old Friends, John Bradley, a volunteer at the farm, became, as John would say, "his human." The two would be seen together almost every day, as John would turn him out and bring him back in.

Then, on October 26, 2015, at age thirty, Mixed Pleasure was euthanized due to colic. "It's always heartbreaking to lose one of our

horses, but at the time of his death, Mixed Pleasure was surrounded by those who loved him most," said Michael Blowen. "Our vet, Dr. Bryan Waldridge, was here to help him, as were our farm managers Tim Wilson and Carole Oates. Most importantly, Mixy spent his last moments with his best friend, John Bradley, one of our dedicated volunteers who was Mixed Pleasure's friend and caretaker these last three years.…Mixed Pleasure was one of the kindest and easy going stallions we've ever had, and he will be sorely missed."[135]

After Mixed Pleasure's death, John took some time to share his thoughts about his favorite horse:

> *When I started at Old Friends as a volunteer, Mixed Pleasure was a newly arrived 27-year-old retiree. At first I was awestruck by his Seabiscuit lineage. However, it did not take long for me to realize that wasn't the only thing that made him special. As our friendship started to develop I began to admire him on many different levels. At the time I never realized that in the next three and a half years he would become the horse that would change my life forever.*

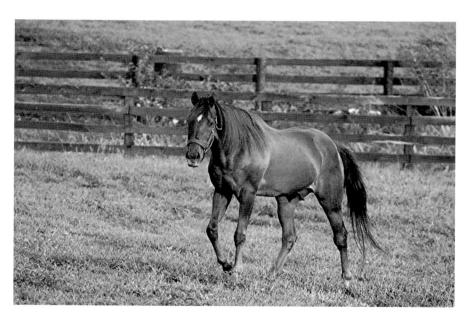

Mixed Pleasure, a favorite of Old Friends volunteer John Bradley, walks across his paddock to greet a visitor. *Courtesy of author.*

The first thing I noticed was how he interacted with visitors. He was a stallion, but had a unique sense of kindness and patience. Next was his large eyes; one could sense a horse that was very wise; however, he seemed to have the ability to gaze into the center of a person's soul. Finally, I rarely had seen a horse that enjoyed interacting with people even when treats were not being offered. Due to the condition of his teeth he wasn't able to enjoy solid pieces of carrots offered during tours. As a solution I began to offer him shredded carrots and a deeper bond was formed.

As time passed I became as dependent on him as he did of me. I had become his friend and caretaker and he became an instructor that would teach me how to care for a horse. I knew in the back of my mind that this love, admiration, and devotion would come with a price. I knew the day would come when I would have to say goodbye to my dear friend. That day arrived on October 26, 2015.

I received a call from farm manager Tim Wilson. He told me I needed to get to the farm as quickly possible. Tim didn't say what the issue was, but by the sense of urgency in his voice I knew in my heart that something had happened to my friend. Upon my arrival he and Dr. Bryan Waldridge explained that Mixed Pleasure had developed colic and after all remedies had been exhausted, humane euthanasia was the best solution due to his advanced age of 30.

I led my friend to a turnout paddock and when I released the lead he immediately laid down on the ground. I could tell by the look in his eyes that the will to go on was there, but his body had given out on him. After he was sedated and just prior to the procedure, I whispered in his ear, "Please forgive me for the decision I made about your fate, but it's in your best interest so you don't suffer. You will always be the greatest horse ever born, I love you." A few seconds later he was gone. At the time of his death he was surrounded by many friends and left this world with peace and dignity and isn't that what all of us can only hope for.[136]

There is a heartwarming postscript to John's story about Mixed Pleasure. While losing Mixed Pleasure was a sad loss, especially for John, about a year later, on October 6, 2016, Windy Road, one of the last foals sired by Mixed Pleasure, arrived at Old Friends to enjoy his retirement. Possessing the good looks of his sire, Windy Road and John became fast friends.[137]

SEA NATIVE
BY LINE IN THE SAND-MISS BIG PIE, BY BIG BLUFFER

Sea Native was foaled in Florida on April 2, 1999. According to the Old Friends website, he mostly ran in allowance races at Gulfstream Park, Calder and Hialeah Park and won two times, finished second three times, third five times and earned $64,760.[138]

Upon retirement, he became a pleasure horse/hunter/jumper for his owner, Angela Black of Georgia, until injury prevented him from being ridden, so Angela looked for a place to retire him.

She did some research and learned about Old Friends. She liked what she read and sent a letter to Michael Blowen, "one of the most beautiful letters" he ever read, to ask if he would take Sea Native in. Michael agreed, and "Rhett," as she called him, was pensioned at Old Friends in 2009.[139]

Sea Native seemed to really enjoy his time at Old Friends, and Angela visited him often. One of the most enjoyable times the two of them got to share together while he was living at Old Friends was when Angela took him to the 2009 Secretariat Festival in Paris, Kentucky, for a Secretariat look-alike contest. The winner of the contest was to get a small part in the upcoming Disney movie about "Big Red."[140]

"Rhett walked happily around the ring, as game as ever," said Angela. "He finished second that day, but a photo taken at the time shows a happy and relaxed horse just glad to be there."[141]

Sadly, as he got older, he suffered from a number of maladies, including cancer, and on Saturday, June 25, 2016, he was euthanized. Angela had a chance to visit with him shortly before he died. She shared memories of her longtime horse friend:

I loved him the moment I laid eyes on him; he had my heart. When I was with him I was that ten-year-old little girl who had always dreamed of a tall handsome chestnut with white socks. I called him "Rhett" because I related it to the word retro, meaning reminiscent of earlier times or relating to the past, much like the love the ten-year-old girl had for horses.

When I lost my beloved Rhett, a big piece on my heart went also. He brought so much joy to my life. I gather, from all the kind words shared at his passing, that he brought a great deal of joy to Old Friends as well. I am so grateful that he was able to live out his last years at Old Friends.

When I would visit, he always seemed content and happy, up until his last days. On our last visit together, when I went to greet him in his

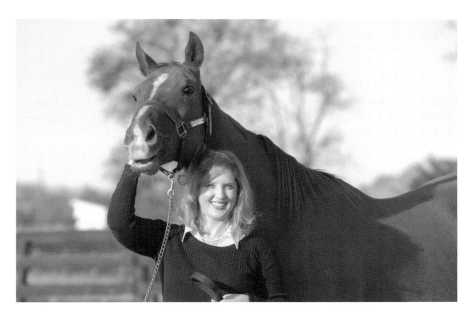

Angela Black visited her horse, Sea Native. In this photo, it's hard to tell who's smiling more, Sea Native or Angela. *Courtesy of author.*

paddock, he made his way to me in such a difficult gait. As we met up, he breathed a weary sigh. I felt his time was nigh.

During our last moments together, we spent time doing our favorite things: grooming, scratching his itchy spot on his neck and munching baby carrots, under the cool comfort of a fan in the barn. All the while, I whispered "Remember the time" stories into his ears.

When the time came, he crossed over the bridge surrounded by love. The most endearing words of comfort came from Carole Oates, an assistant farm manager at Old Friends, and they rang so true. She said, "He is at peace and he had a good life."[142]

Interestingly, when she originally brought Sea Native to Old Friends, Angela was afraid he might forget her in time. Well, that never happened, as she explained:

Anyone who knows the spirit of the Thoroughbred understands that champions aren't always made by the number of trophies on a shelf. And that the size of a great horse's heart isn't always measured by the number of

victories in a win column. As Rhett's life drew to a close, the friend he never forgot came to say goodbye. And to the last, he remained kind and gentle, grateful and honest, with the heart of a true champion.[143]

HIDDEN LAKE
BY QUIET AMERICAN-FRIENDLY CIRCLY, BY ROUND TABLE

Hidden Lake was one of the most majestic mares ever to live at Old Friends. Foaled on April 2, 1993, at Nuckols Farm in Midway, Kentucky, she earned the 1997 Eclipse award as Champion Older Mare for her success on the track.

The beautiful bay mare raced from 1995 to 1997. While she won one graded stakes race as a three-year-old in 1996, the La Brea Stakes (G2) at Santa Anita, it was as a four-year-old in 1997 when she had her best season, winning four stakes races, three of them graded stakes: the Shuvee Handicap and the Hempstead Handicap (G1), both at Belmont Park, and the Beldame Stakes (G1) at Belmont.

Hidden Lake, the 1997 Champion Older Mare, was an irreplaceable friend to Barbara Fossum. *Courtesy of author.*

Her biggest win that year, and the one most people always remember, was her courageous victory in the Go for Wand Stakes (G1) at Saratoga. In the race, she rallied back twice in the stretch and with one final lunge at the wire won by a head. She had given so much of herself in the race that when she was pulled up, her jockey, Richard Migliore, felt her stumble. She was diagnosed with heat prostration and hosed down to cool her off before heading to the winner's circle.

After the race, Migliore said of her win, "She reached down and found something that wasn't there. That's what champions do."[144]

For her efforts that year, she was named Champion Older Mare. Retired after that season, she ended her career with seven wins, four seconds, six thirds and $947,489 in earnings in twenty-two starts.[145]

As a broodmare, she had increasing problems carrying foals to terms, so in 1999, her then owner, Robert S. Evans, donated Hidden Lake to Old Friends.[146]

One of Old Friends' volunteers, Barbara Fossum, was a big fan of Hidden Lake. When she learned the mare was coming to Old Friends, she showed Michael Blowen a large scrapbook she had made detailing Hidden Lake's career. Needless to say, Hidden Lake and Barbara bonded and spent many days together.

On September 29, 2016, after enjoying seven years of retirement at Old Friends, Hidden Lake was euthanized due to the infirmities of old age. "Hidden Lake defined bravery, determination and courage," said Barbara about her equine friend. "She was dignified and generous to those who loved her—demanding and all heart. She personified everything an Eclipse Champion should be."[147]

WALLENDA
BY GULCH–SO GLAD (ARG.), BY LILOY

Wallenda was one of the most regal, dignified and courageous Thoroughbreds to ever call Old Friends home.

Foaled in Florida on April 24, 1990, Wallenda was named after the famous aerialist Karl Wallenda of the Flying Wallendas. He was bred by Peter M. Brant and Haras Santa Maria de Araras and later purchased by Cot Campbell's Dogwood Stables.[148]

Wallenda's racing career lasted four years between 1992 and 1995, and during that time, he won four graded stakes. In 1992, he won the Cowdin

Stakes (G2) at Aqueduct; in 1993, he won the Super Derby (G1) at Louisiana Downs and the Pennsylvania Derby (G2) at Philadelphia Park; and in 1994, he won the Stuyvesant Handicap (G3) at Aqueduct. He also won a non-graded stakes race that year at Suffolk Downs, the Suffolk Downs Breeders' Cup Handicap.

His win in the Louisiana Super Derby is considered his greatest victory. In that race, he beat Saintly Prospector at the wire for the $400,000 purse.[149] In his career, he had seven wins, five seconds and five thirds and earnings of $1,205,929.[150]

Wallenda entered stud in 1995, first in New Zealand and later at Toyosato Stallion Center in Hokkaido, Japan. When his stud career was over, Old Friends, "with the help of Dogwood trainer Frank Alexander, members of the stallion's syndicate, and loyal supporters, returned Wallenda to the United States in [April] 2007."[151]

After arriving home, the dark-brown/brown beauty had ongoing issues with his feet. But thanks to the care of many different doctors and foot specialists, especially Dr. Bryan Fraley, and Wallenda's courage and grit, he enjoyed many years of retirement.

In describing Wallenda and his foot problems, Michael Blowen said, "When Dogwood Stable's Cot Campbell named Wallenda after the great high wire artist Karl Wallenda 26 years ago, I don't think he imagined that the son of Gulch would become the equine embodiment of his namesake. Wallenda's life was like crossing the Grand Canyon every day on a thin wire, with only determination and audacity keeping him from the abyss. He lived by his courage and wits and toughness. Ironically, both Wallendas, who lived by their extraordinary feet, were, ultimately, betrayed by them. We have…and had…more lovable horses at Old Friends, but none of them could surpass the determination and resilience of the incomparable flying Wallenda."[152]

After Wallenda was settled in at Old Friends, a special day was held in his honor. Many people attended, including the Flying Wallendas.

Wallenda enjoyed nine years at Old Friends, but on May 9, 2016, at age twenty-six, he was euthanized due to complications brought on by a collapsed suspensory. In Wallenda's obituary, Michael said:

> *He was, by any definition, a warrior. Like his sire, Gulch, who was also with us for many years, Wallenda was one of the toughest and most resilient horses we have ever known.*

Wallenda, a favorite of Old Friends farm manager Tim Wilson, enjoyed a nine-year retirement at the farm. *Courtesy of author.*

> *Despite his ongoing hoof issues, he maintained a gleam in his eye and vibrant attitude. But today his demeanor changed, and after much discussion with our vet, Dr. Bryan Waldridge, the vets at Hagyard, and the amazing farriers at Dr. Bryan Fraley's Equine Podiatry, we felt Wallenda's medical issues had reached the point where we could no longer maintain his comfort or quality of life....He was a favorite here on the farm and we will miss seeing him every day.*[153]

Wallenda also became a favorite of Tim Wilson, Old Friends' farm manager, who said:

> *Wallenda was the toughest horse I have ever known in twenty-five years with Thoroughbreds and racehorses. If I made a list of my top ten role models in life, nine on the list would be people, but one spot would be reserved for a horse. That horse is Wallenda.*
>
> *He never quit. Never gave up. Never seemed to acknowledge the immense challenge he faced until the last few days when even he couldn't change the reality.*[154]

GULCH
BY MR. PROSPECTOR-JAMEELA, BY RAMBUNCTIOUS

Gulch was foaled in Kentucky on April 16, 1984, and in his racing career he won thirteen times, finished second eight times, third four times and earned $3,095,521 in thirty-two career starts.

His biggest win came in 1988, when he won the Breeders' Cup Sprint Stakes (G1) at Churchill Downs. He also won two other Grade 1 races that year: the Metropolitan Handicap at Belmont Park and the Wood Memorial Invitational at Aqueduct. With those wins, and a few others, he won the Eclipse award as 1988 Champion Sprinter.[155]

Upon retirement, Gulch stood at William S. Farish's Lane's End Farm in Versailles, where he was a successful sire.

According to the Old Friends website, "His most notable offspring is 1995 Kentucky Derby and Belmont Stakes winner Thunder Gulch. Other Grade 1 winners include Court Vision, Great Navigator, The Cliff's Edge, and Wallenda. In all, Gulch is represented by 71 stakes winners—30 of which are grade or group winners—72 stakes-placed runners and the earners of $80 million."[156]

When his stud career was over, he was graciously donated to Old Friends. At the time, Farish noted that the stallion's popularity with fans influenced the farm's decision to send him to Old Friends. "He was a horse that was well known to the public having been through the Triple Crown trail and having been a top two-year-old and a champion sprinter," said Farish. "He was a horse that people always wanted to see. Plus, he's kind of a ham, and he will enjoy the attention immensely."[157]

Gulch was very popular at Old Friends, with many people coming specifically to see him. He was even visited by his first trainer, Hall of Famer LeRoy Jolley, a few times. "As LeRoy Jolley, who was Gulch's first trainer, once said, 'Gulch must be the toughest horse who ever lived,' and he was," noted Michael. "He was confident, self-possessed and regal. He didn't demand respect—he earned it. He is irreplaceable."[158]

As time passed, Gulch grew older, and at age thirty-two in 2016, he became Old Friends' oldest retiree. In addition, at the time, he was the oldest Breeders' Cup champion.[159]

Sadly, on January 17, 2016, with a heavy heart, Michael announced the passing of Gulch due to complications from cancer. Following Gulch's death, many people sent in cards and letters of sympathy for

their favorite horse. Social media was also filled with the news of the great champion's death.

One of Gulch's biggest fans was Laura Hillenbrand, author of the *New York Times* bestsellers *Seabiscuit: An American Legend* and *Unbroken: A World War II Story of Survival, Resilience and Redemption.*

On her Facebook page, Laura wrote a beautiful essay about Gulch and what he meant to her when she was growing up:

Goodbye, Sweet Gulch.

In 1987, when I was young and desperately ill, I wrapped my heart up in horse racing. Watching the paradox of mass and lightness that is the Thoroughbred, I could briefly forget my own broken body and live instead in his. That season, a horse named Gulch came along. He was everything: scorchingly fast yet long on stamina, beautifully crafted, hell-for-leather tenacious. He left the track long ago, but I never lost my gratitude for the thrilling escape he gave me.

Last fall [2015], when my boyfriend and I were planning a road trip across America, we had a thousand wonders to choose from, but there was

Gulch, who was donated to Old Friends by Lane's End Farm, was special to best-selling author Laura Hillenbrand. *Courtesy of author.*

one place I felt I had to go. It was Old Friends Equine Retirement, where Gulch lived. Then an unlikely 31 years old, he had proven as enduring in old age as he'd been brilliant in youth. A longtime supporter of Old Friends, I had been corresponding with the farm's founder, Michael Blowen, and always inquired about Gulch, asking Michael to walk by his paddock and give him a kiss for me. I had long dreamt of going to see the horse, but the trip was so far beyond what my ailing body had ever been able to do. When my health improved and I began to believe I could traverse the country, I thought long and hard about going to Old Friends. Swinging south to Kentucky would add days to a journey that was already an extremely risky leap for me, but I had to see Gulch in his waning days. Of the marvelous horses who'd kept me breathing in the early days of my illness, he was the last one left. A horse who had been a part of my life as it fell to pieces was still part of it when I set myself free. I owed him this.

When the RV crunched up the driveway and pulled up at Old Friends, Michael hurried out, gave me a big hug, and pointed to a distant paddock. "There he is," he said. I could see only a brown form, far away, in a vivid sea of green. We rode into his paddock on a golf cart. There Gulch stood, surrounded by caretakers, who were gently giving him acupuncture. The sun, setting behind him, lit up his coat in an amber penumbra. As we drove up, his sleepy eyes grew worried, his crooked ears flipped forward, and he raised his head in alarm. Michael stopped the golf cart, knowing it was unsettling the horse. I walked up and stroked Gulch's face, and they let me hold his lead while they worked on him. He was gentle and so kind, murmuring his lips against my fingers. He looked impossibly youthful for his age, which was roughly 100 in human years. I stood a long while with him, stroking his face and neck and whispering my thanks for what he'd given me so long ago. I'd never felt so privileged.

He was so very old. In the two days that we stayed at the farm, I spent many hours just watching him as he ambled about his paddock. Michael told me that they worried over him, knowing he couldn't go on forever. Sometimes he'd lie down in the grass and they'd fear he was gone. They'd rush out to the paddock, calling his name. Not wanting to be bothered, he'd wave an ear at them, and they'd stop, laughing, and let him enjoy his sunbath.

As we drove out of Old Friends, I called out my goodbyes to Gulch, knowing I would not see him again. I turned all the way around in my seat

to get a last glimpse of him. He was cruising around in the grass, at peace and full of years.

Gulch died yesterday morning. He was 32 years old. Thank you, old friend.[160]

Chapter 18

OLD FRIENDS AT CABIN CREEK

*T*he beauty of Old Friends at Cabin Creek: The Bobby Frankel Division, which is owned by JoAnn and Mark Pepper, has to be seen to be truly appreciated. The words *stunning, breathtaking* and *gorgeous* don't even begin to describe the beauty of the farm.

As you make the turn into the farm and drive down the entrance road toward the barn, you are surrounded by red and white pine trees that seem to reach to the sky. Then, as you reach the slight rise at the end of the road, the farm opens up in front of you like a Norman Rockwell painting, with paddocks filled with horses as far as the eye can see. The barn is on the left next to a paddock full of green grass the color of emeralds, while up on the hill to the left is the home of JoAnn and Mark.

What makes the farm even more amazing is when you consider that almost everything you see was built by Mark. He cleared the land, staked out the paddocks, fenced them in and also hand-crafted the run-in sheds found in each of the horses' paddocks.

Mark also built the barn, which is very well maintained. It includes twelve stalls and a recently completed gift shop. It was a lot of work but definitely a labor of love that has paid off wonderfully, as visitors come from all over to see the horses.

Opened in 2009, the original name of the farm was Old Friends Cabin Creek. However, after the death of Hall of Fame trainer Bobby Frankel, a big supporter of Old Friends, Michael renamed the farm Old Friends at Cabin Creek: The Bobby Frankel Division in his honor.

The farm is located in Greenfield Center in New York, just a few minutes away from Saratoga, where Frankel, who was a native of New York, raced many of his horses. Here are a few stories about some of the horses that call Old Friends at Cabin Creek home.

BE BULLISH
BY PURE PRIZE-SMART HOLLY, BY SMARTEN

Be Bullish was foaled in New York on February 25, 2005. His original owners were Carol and Herbert Schwartz, but over his nine-year racing career, he was also owned by others, including Mike Repole.

Be Bullish won his first race and went on to become a multiple (ungraded) stakes winner. Then, on Sunday, May 17, 2015, a ten-year-old Be Bullish won a $16,000 claiming race by three lengths at Belmont Park. It was his fourth consecutive win and was also the final race of his career. At the end of the race, he was claimed by David Jacobson and Drawing Away Stable for Repole, who wanted to retire him to Old Friends at Cabin Creek.

"All great athletes have to retire some time, and not too many great athletes get to retire at the top of their game," said Repole. "That he won four in a row makes for a cooler story, but he's got close to ninety starts, 50 percent firsts or seconds and churned out more than $1 million."[161]

The beautiful gray/roan Thoroughbred ended his career with nineteen wins, twenty-six seconds, fourteen thirds and $1,106,288 in earnings in eighty-seven starts. He was only the thirtieth New York–bred to win more than $1 million.[162]

COOL N COLLECTIVE
BY RUHLMANN-PANTHER RUN, BY COX'S RIDGE

Cool N Collective, a brown gelding, was foaled in Ontario, Canada, on March 22, 1997. His sire, Ruhlmann, was also a retiree at Old Friends in Kentucky.

He began his racing career in 2010 at age three and raced in Canada and the United States until 2012, when he was thirteen. He won ten races in his

career, with his biggest being the Elgin Stakes at Woodbine in 2000. Upon retirement, he had ten wins, fourteen seconds and eight thirds and $200,194 in earnings in forty-nine career starts.[163]

Cool N Collective is another Cabin Creek retiree who came from Repole, and his retirement came about in an interesting way. According to the Old Friends website, "He was presented to JoAnn Pepper and Michael Blowen on Memorial Day at Aqueduct prior to the sixth race. The sixth race on that specific day was designated as the Cool N Collective Day, his official day of retirement."[164]

COMMENTATOR
BY DISTORTED HUMOR-OUTSOURCE, BY STORM BIRD

Commentator was foaled in New York on March 27, 2001, and had many great wins in his career. However, his biggest wins, the ones that made him a fan favorite in New York, were his two wins in the Whitney Handicap (G1) in 2005 and 2008.

In his career, the loveable chestnut gelding also won the Perryville Stakes at Keeneland in 2004, the Mugatea Stakes at Belmont in 2006 and the Richmond Runner Stakes in 2007. Then, along with his second win in the Whitney in 2008, he put on an amazing performance to win the Massachusetts Handicap at Suffolk Downs by fourteen lengths.[165]

In 2009, he won the Kashatreya Stakes at Belmont and then finished third in the Whitney Stakes in his final race. Commentator retired with nine wins, one second, four thirds and $1,869,153 in earnings in nineteen starts.[166] He was pensioned to Old Friends in Kentucky in October 2009, thanks to his owner, Tracy Farmer. He was then moved to Cabin Creek in 2015 to be closer to his New York–based fans.

According to the Old Friends at Cabin Creek website, "Commentator set two track records and at the age of seven held the highest Beyer speed figures for distances both under and over a mile. His retirement, in September 2009, was honored at Saratoga with the first running of the Commentator Stakes. He galloped onto the track to lead the post parade, and then received a peppermint Key to the City of Saratoga Springs."

Today, Commentator's popularity remains as strong as ever, as visitors come to see their favorite New York–bred Thoroughbred, and "Tator" enjoys the attention and, of course, the carrots.

Commentator kicks up his heels in happiness at Old Friends at Cabin Creek. *Courtesy of Connie Bush.*

DRIVEN BY SUCCESS
BY PRECISE END, OUT OF AFLEET CLOSER, BY AFLEET

Driven by Success, a chestnut gelding, was foaled in New York on April 8, 2005. In his career, he won nine times, finished second five times, third five times and earned $607,099 in thirty-five career starts.[167]

His biggest wins were all restricted stakes races: the Hudson Stakes in 2009 at Belmont Park; the New York Stallion Thunder Rumble Stakes at Belmont Park, which was named after Cabin Creek's retiree Thunder Rumble, and the Vic Ziegel Memorial Stakes at Saratoga, both in 2010; and the Easy N Dirty Stakes at Saratoga in 2011.

Upon retirement, Driven by Success was another horse donated by Repole and arrived at Cabin Creek on September 18, 2012.[168]

KARAKORUM PATRIOT
BY PERSONAL FLAG, OUT OF LUCKY LADY SUSITA, BY DISTINCTIVE PRO

Karakorum Patriot was foaled in New York on May 1, 2000. In his career, he mostly ran at Finger Lakes, his home track. There he faced a former Cabin Creek retiree, Midnight Secret, a number of times.

He ran in eighty-nine races during his career, winning thirteen times and earning $347,503. All of his wins came in claiming and allowance races, although he did run in a few stakes races, such as the Mugatea Stakes at Belmont, the Hudson Handicap at Belmont and the Wine Country Handicap, which he placed in at Finger Lakes.[169]

When retired, according to the Old Friends website, plans were being made for him "to race in Puerto Rico. This attracted the attention of many people such as his breeder Richard Zwirn of Rainbow Stables, Susan Hamlin, Joy Dunn, Karakorum Racing, who campaigned him from 2003–2006, and a woman named Dara who fell in love with him and his story." They wanted to retire him, which they did.[170]

A beautiful chestnut gelding, Karakorum Patriot arrived at Cabin Creek along with Midnight Secret on December 4, 2009.[171]

Sadly, on May 8, 2017, Karakorum Patriot died due to a paddock accident.

Karakorum Patriot always seemed to enjoy life, as he shows here by bucking and kicking up his heels. *Courtesy by Connie Bush.*

MIDNIGHT SECRET
BY KEY CONTENDER-FLANNEL SHEETS, BY TRIOCALA

Midnight Secret was foaled in New York on February 21, 1998, and began his racing career as a two-year-old and raced until he was twelve. To say he was a "war horse" would be an understatement. He ran in 111 races, won fourteen times, was second thirty-one times, third twenty times and earned $212,749.[172]

The races were maiden, claiming and allowance races at Aqueduct and Belmont and then Finger Lakes when his trainer, Oscar Barrera Jr., moved him there. At Finger Lakes, he raced against fellow Old Friends retiree Karakorum Patriot.

Upon retirement, Midnight was donated to Old Friends and arrived along with Karakorum Patriot on December 4, 2009. Coincidentally, Midnight's sire, Key Contender, was a former retiree at Old Friends at Cabin Creek. Midnight died on June 29, 2012.[173]

RED DOWN SOUTH
BY DIXIE BRASS-REDEYE RAIN, BY INSTRUMENT LANDING

Red Down South, a beautiful chestnut gelding, was foaled in New York on April 24, 2000. His racing career was one of hard work on the turf, with only a handful of good results. In total, he ran thirty-two times, had two wins, three seconds and four thirds and earned $116,650. His biggest racing accomplishment came in 2005 in the Cormorant Stakes at Aqueduct, where he finished third.[174]

In his final race on August 11, 2007, he was ridden by Hall of Fame jockey Calvin Borel in an Allowance Optional Claiming race at Saratoga and finished ninth. The chart noted that he was "wide throughout, tired."[175]

Red Down South was retired and arrived at Old Friends on February 17, 2010, thanks to owner/trainer Dennis Brida, and lives in a paddock with his good buddy, Zippy Chippy.[176]

In another of those Old Friends coincidences, Red's sire, Dixie Brass, was also trained by Dennis Brida, and he finished second in the 1992 Jim Dandy. The winner of that race was Old Friends retiree Thunder Rumble.[177]

ROARING LION
BY LION HEARTED-SMARTLY, BY HORATIUS

Roaring Lion was foaled in Maryland on April 7, 2004. A gelding, he was owned by Mike Repole. He began his racing career as a two-year-old in 2006 and raced until 2012 as an eight-year-old.

He won a number of (ungraded) stakes races, including the Maryland Juvenile Championship Stakes in 2006 at Laurel; the Maryland Million Sprint Handicap in 2009 at Laurel; the Teddy Drone Stakes and the Mr. Prospector Stakes, both at Monmouth in 2010; and the Mr. Prospector Stakes at Monmouth in 2010 and again in 2011, this time on the Fourth of July.

Trained by Todd Pletcher, Roaring Lion won twelve times, finished second four times, third six times and earned $542,536 in thirty-two career starts.[178] He arrived at Cabin Creek in September 2011 thanks to Repole.[179]

STRUMMER
BY PHONE TRICK-MANOR QUEEN, BY WAVERING MONARCH

Strummer was foaled in New York on March 18, 2003, and is one of the newer retirees at Cabin Creek. In his career, he raced in fifty-six races, won twelve times, finished second nine times, third five times and earned $409,051. His biggest win came in 2006 in the Jimmy Winkfield Stakes at Aqueduct.[180]

Strummer was retired in November 2012 from Stonegate Farm in Fort Edward, New York, and came to Old Friends in the fall of 2015.[181]

THIS HARD LAND
BY SAARLAND-SUPAH SASSY, BY GOLD MERIDIAN

This Hard Land was foaled in New York on March 17, 2008. "Frankie," as he is nicknamed, after the Bruce Springsteen song, raced for six years in claiming, allowance and three stakes races, one of which was the Commentator Stakes. He won seven times, finished second eight times, third seven times and earned $451,221 in forty-nine career starts.[182]

This Hard Land, who became a New York fan favorite, arrived at Old Friends in March 2016 and lives close by Commentator, the namesake of a race he won.[183]

WATCHEM SMOKEY
BY ALPHABET SOUP-KARON'S DREAM, BY GEIGER COUNTER

Watchem Smokey was foaled in Oklahoma on February 26, 2000. He began his race career as a two-year-old and won two times. He finished his career in 2009 as a nine-year-old.

His first six starts were under trainer Cecil Borel, the brother of Hall of Fame jockey Calvin Borel. He was then purchased by Bobby Frankel. At the time of the purchase, Smokey was one of the top sprinters out west.

According to the Old Friends website:

> [Smokey's] *first big win* [was] *in the Airline Stakes at Louisiana Downs in 2003, and after he raced in an allowance race, he won the 2003 Vernon*

O. Underwood Stakes (G3) at Hollywood Park in 2003 with jockey Julie Krone aboard. After this big win, he continued to work his way to the top. Tragedy stuck when he was unable to avoid a fallen horse in a stakes race at Santa Anita [in the Potero Grande Stakes] *(G2).*

After this, he never fully regained his old form, but was still a successful horse. After a few more races, Smokey was claimed for $100,000 at Keeneland, but did wind up winning three more stakes races including the Delta Mile, the John Henry Stakes, and the Gulf Coast Classic, all at Evangeline [in 2006]....*Eventually, time caught up with him, and Smokey went back to the bottom in claiming races. In his last race in 2009, he blew the ligaments in his front left leg.*

His new owner, Kelly Benjamin, who claimed him, was told euthanasia was her best option. She knew he was a fighter and went against what they advised her. The Oklahoma Thoroughbred Retirement Foundation donated that month's funds to rehabilitate him. Despite his injury, Smokey came in third in his last race.[184]

Upon retirement, Smokey had five wins, seven seconds, seven thirds and $272,997 in fifty career starts, which included five stakes races.[185] Originally, Smokey was at the main farm in Kentucky, but he was sent to Cabin Creek in March 2010.

WILL'S WAY
BY EASY GOER-WILLAMAE, BY TENTAM

Will's Way was foaled in Kentucky on April 22, 1993. He was originally retired at Old Friends in Georgetown but was moved to Cabin Creek on June 25, 2010, because that's where he won his biggest races and had a big following.

In all, Willy, who was trained by H. James Bond, won six races, was second two times and third three times and earned $954,400 in thirteen career races.[186] His biggest wins both came in New York at Saratoga. In 1996, he won the Travers Stakes (G1), and in 1997, he won the Whitney Handicap (G1). His win in the Travers was especially exciting, according to the Old Friends website:

The year was 1996. [Will had] almost won the Jim Dandy, but was beaten by a nose by Louis Quatorze, who won that year's Preakness Stakes. Seeking revenge, a determined Will's Way destroyed the field in the Travers, which included Editor's Note who came in third in the Preakness and won the Belmont, and Skip Away, who placed in the Preakness and Belmont. Will's battle with Louis Quatorze was an intense one. They battled right to the end, but Will prevailed and would not let the Triple Crown contenders be in front of him again. Skip Away was third and Editor's Note was a distant fourth.[187]

Willy also ran in the Breeders' Cup Classic (G1) that year and finished seventh. Then, in 1997, Willy once again faced Skip Away and Editor's Note in the Whitney Stakes (G1) and once again beat both of them.

Upon retirement, "Willy" was retired to stud, where "he sired 171 foals, including multiple graded stakes winner Lion Tamer [who in turn sired multiple stakes winner Heavy on Themister]. He also sired four other stakes winners, 11 placed-stakes runners, and earners of over $5.9 million."

When his stud career was over, Will was pensioned and donated to Old Friends.[188]

ZIPPY CHIPPY
BY COMPLIANCE-LISTEN LADY, BY BUCKFINDER

Zippy Chippy was foaled in New York on April 20, 1991, and has one of the most unique stories in all of Thoroughbred history. Nicknamed the "Losingest Horse in History," Zippy ran in one hundred races, and while he did have eight seconds and twelve thirds and earned $30,834, he never won a single race.

According to the Old Friends website, "His losing streak made him famous; so famous that he had a following [of] people who would go to all his races, some hoping for the streak to end, and others just looking to see how long he would go on losing."[189]

During his career, Zippy also was a bit of a troublemaker at the track. Some of his antics included not leaving the gate, stopping in the middle of a race, biting and a host of other things. As a result, he was banned from many tracks in America. Still, his owner, Felix Monserrate, found places to race him, which he did until Zippy lost his 100th race, at which point he was retired.

Red Down South, *right*, and Zippy Chippy are inseparable buddies at Old Friends at Cabin Creek. *Courtesy of Connie Bush.*

Zippy also ran in a number of "exhibition" races—two times against athletes and once against a harness racer.

After his retirement, Felix kept him for a few years until he decided that Old Friends was the perfect place for a horse like Zippy. Of course, getting him to Old Friends was no easy chore. According to Michael Blowen, "It was one of the hardest negotiations he had ever had to go through."[190]

Once at Cabin Creek, Zippy was placed in a paddock with Red Down South, and from the first time they met, they have been the closest of friends. You'll never find them more than a few feet apart.

While Zippy never won a race, and while people always talk about his losing streak, Michael described Zippy another way: "Winners don't always finish first." And judging by the number of people who come to Cabin Creek to see him, the saying fits perfectly.

To learn the fuller story of Zippy Chippy, you can read a wonderful account of his life by William Thomas in *The Legend of Zippy Chippy: Life Lessons from Horse Racing's Most Lovable Losers*.

GONE BUT NOT FORGOTTEN

CABIN CREEK

*A*s happens in everyday life, Old Friends at Cabin Creek has lost a few of its retirees. Sometimes it's old age, sometimes colic or lamintus and sometimes it's just their time. While there have been a few deaths, the most notable loss was Thunder Rumble, winner of the 1992 Travers Stakes and the first stallion to call Cabin Creek home. Here are their stories.

THUNDER RUMBLE
BY THUNDER PUDDLES-LYPHETTE (FR.), BY LYPHARD

Thunder Rumble was the first big-name stallion to call Cabin Creek home. He was also a fan favorite in New York, as he had some of his biggest wins at New York tracks.

Thunder Rumble was foaled in New York on March 31, 1989. He raced for three years between 1991 and 1994 but did not race for almost two years between 1993 and 1994 due to an injury.[191]

By far his biggest win was the Travers Stakes (G1) at Saratoga in 1992 as a three-year-old. At the time, he was the first New York–bred Thoroughbred to win the race. Upon retirement, he had eight wins and one third and $1,047,552 in earnings in nineteen career races.[192]

When he arrived at Old Friends in 2009, he became the favorite of farm owner JoAnn Pepper. At first, the dark-brown/brown stallion would "test her," but the two finally learned to get along and love each other.

Thunder Rumble, the first stallion at Old Friends at Cabin Creek, and farm owner JoAnn Pepper enjoyed their time together. *Courtesy of Connie Bush.*

At Old Friends, Thunder Rumble and Will's Way, another Travers Stakes winner, were in adjoining paddocks, and there were times you'd see the two of them racing each other down the fence line. Two great Thoroughbreds running side by side, especially in the snow, was a beautiful sight to behold.

Sadly, on January 6, 2015, a few days after his birthday party, the "beautiful 17 hand Alpha leader at Old Friends," Thunder Rumble, died from colic.[193] An Old Friends press release noted his passing:

> *After six years of happy retirement at Old Friends at Cabin Creek in Greenfield Center, Thunder Rumble, the 26-year-old New York bred stallion and 1992 winner of The Travers Stakes died Tuesday with farm owners JoAnn and Mark Pepper, his loving family of caretakers, and volunteers by his side. His death was due to complications from colic. Thunder Rumble was the Alpha stallion at the farm and left an enduring impression on everyone he met. His illness and death was very sudden.*[194]
>
> *Said JoAnn at the time, "With a broken heart, I'm writing to tell you that…on January 6, 2015, we lost our majestic Alpha leader due to complications from colic. He was a magnificent dark bay stallion at 17 hands and he took his job as leader seriously at Old Friends at Cabin Creek."*

"He was the most magnificent stallion I have ever met and am so thankful to have known him and loved him. He enjoyed every minute of his birthday party on Saturday (Jan. 3, 2015), even had a Cabin Creek Travers race with Wills Way. I'm glad so many people came to see Thunder and all his friends, not knowing we would have to say goodbye so soon. He is buried here, in his favorite place, under his pines. Be free my friend, till we meet again."

BEHRENS
BY PLEASANT COLONY-HOT NOVEL, BY MARI'S BOOK

Behrens was foaled in Kentucky on February 24, 1994. During his racing career, he won nine times, finished second eight times, third three times and earned $4,563,500 in twenty-seven career starts.

His biggest wins came in two different years. In 1997, as a three-year-old, he won the Buick Pegasus Handicap (G2) at the Meadowlands and the Dwyer Stakes (G2) at Belmont. Then, in 1999, he won the Oaklawn Handicap (G1) at Oaklawn Park, the Massachusetts Handicap (G2) at Suffolk Downs, the Suburban Handicap (G2) at Belmont and the Gulfstream Park Handicap (G1) at Gulfstream Park, which he also won in 2000.[195]

Behrens, a multiple stakes winner, lived a happy retirement at Old Friends at Cabin Creek. *Courtesy of author.*

He arrived at Old Friends in the summer of 2013 and enjoyed a nice retirement, but on September 17, 2014, at age twenty, he passed away following a brief illness. "It won't be the same without Behrens," said JoAnn at the time, as she fondly remembered the stallion as a "vocal" and kind horse. "I'm glad to have known him."[196]

CRUSADER SWORD
BY DAMASCUS-COPERNICA, BY NIJINSKY II

Born in Virginia on April 7, 1985, Crusader Sword had one of the richest pedigrees on the farm in his sire, Damascus, and broodmare sire, Nijinsky II.

In his three-year racing career between 1987 and 1989, he raced twenty-one times, scoring six wins, three seconds, five thirds and $327,476 in earnings in twenty-two starts. His most notable wins both came at Saratoga in 1987, when he won the Hopeful Stakes (G1) and the Saratoga Special Stakes (G2).[197]

After his racing career, he stood at stud for a number of years before coming to Old Friends in 2009, where he enjoyed seven happy years of retirement until his death on May 10, 2016, at age twenty-nine. "He had five years of happy retirement as an ambassador for Thoroughbred aftercare. His nickname was Grandpa. He ruled the paddocks at the top of the hill and was loved by everyone. He was gentle with children. He danced for his dinner every night, snorting and tap dancing around his paddock....He's racing in green pastures now with his old friends Rio and Key Contender."[198]

KEY CONTENDER
BY FIT TO FIGHT-KEY WITNESS, BY KEY TO THE MINT

Foaled on February 15, 1998, in Virginia, Key Contender had his biggest win in 1995 when he won the Suburban Handicap (G1) at Belmont Park.[199] Upon retirement, he had fifteen wins, seventeen seconds and six thirds and $839,261 in earnings in fifty-six starts.[200]

He was then retired to stud in 1996 at Highcliff Farm in Delanson, New York, before being pensioned and sent to Old Friends in 2012. Sadly, Key Contender was only at Cabin Creek for a few months before dying on June 29, 2012, due to colic.[201]

Moonshadow Gold
by Golden Gear-Wacky Miss, by Miswaki

Moonshadow Gold was foaled in New York on February 14, 1999, and was the first horse to be retired to Cabin Creek.

He raced until he was ten years old. In that time, he ran in eighty-nine races, mostly claiming and allowances races, and won sixteen times, finished second twenty-three times, third twelve times and earned $338,777.[202]

He arrived at Old Friends in 2009 and enjoyed seven years at Cabin Creek. He died on May 25, 2016. "With a heavy heart, we sadly announce that Moonshadow Gold, the first Thoroughbred to retire with us in 2009, died Wednesday, May 25, 2016, at the farm. He became ill suddenly and passed away peacefully with JoAnn, Mark and several volunteers nearby. Moon was a 17-year-old gelding with a big heart and a loving nature. He loved being groomed and was very fond of treats when visitors came by. We'll all miss him terribly and remember him with much love."[203]

New Export (Brz.)
by Exile King-Important Daisy (Brz.), by Ghadeer (Fr.)

Nicknamed "Rio" in honor of his home country, New Export was foaled in Brazil on July 20, 2001. The biggest wins of his career came in Brazil in 2005 when he won the Gp Estado Do Rio de Janeiro (BRZ-G1) and the GP Francisco Eduardo de Paula Machado (BRZ-G1). For his efforts, he was named Brazil's Champion 3-Year-Old Colt. Upon retirement, he had six wins, three seconds, six thirds and $261,125 in earnings in twenty-five career starts.[204]

He was retired to Cabin Creek in January 2010. Sadly, just a few months later, on July 27, 2010, he died after foundering, which was a complication of Potomac Horse Fever.[205]

Chapter 20

OLD FRIENDS AT
KENTUCKY DOWNS

On January 17, 2015, Old Friends and Kentucky Downs in Franklin, Kentucky, announced in a press release a partnership that would create an Old Friends satellite facility at the historic racecourse:

> *The horse exhibit, "Old Friends at Kentucky Downs," is expected to launch in May 2015 and will be open to the public for the summer season. It will showcase 10 retired racehorses—including athletes with a history of running at Kentucky Downs—via public tours coordinated by the Simpson County Tourism Commission. In addition, an adjoining visitor's center and an Old Friends gift shop will be housed in a newly renovated structure on the Downs stable area....The joint venture is expected to help raise awareness of retired racehorses and the need for Thoroughbred aftercare, to increase tourism and to promote local attractions in Simpson County.*[206]

After a lot of work, Old Friends at Kentucky Downs opened its doors on July 17, 2015. "We're proud to be working with Kentucky Downs and the Simpson County Tourist Commission on this venture," said Michael Blowen in a press release. "This is a great facility and the best part is that we'll be able to introduce these retired athletes to even more fans. This exhibit will offer people a way to maintain emotional ties to the horses and it will also offer a new way to celebrate the history of horse racing in their community."[207]

Added Rick Albright, racing manager at Kentucky Downs, "We are so pleased to be the first live racetrack to provide a home for these former

equine athletes. This is a very unique layout that will allow them to enjoy their retirement in an environment they are accustomed to—a beautiful racecourse. Some of the paddocks even border the outer fence of the course. The horses can look down the homestretch of a track they may have once won races on. That, to us, is a very exciting twist to the Old Friends at Kentucky Downs facility."[208]

One of the fun things that happens each year is when Kentucky Downs hosts "Old Friends Day." On that day, all of the races are named after Old Friends retirees, with the day culminating with the Old Friends Stakes, which, in a play on the Breeders' Cup slogan, is a "Win and You're In" race. Only in this instance, the winner is guaranteed a spot at Old Friends upon retirement.

To get things started at Kentucky Downs, the facility brought in five horses. Four of them—Ball Four, Sgt. Bert, Thornfield and Tour of the Cat—moved from the main farm in Georgetown. One, Rumor Has It, was a new arrival at the time of the opening. Lusty Latin was also moved to Kentucky Downs from the main farm a short time later.

Kentucky Downs also includes a miniature horse named Fonzi, who is trying to do his best imitation as a SpokesHorse like Little Silver Charm. Here are a few stories about the horses at the facility.

BALL FOUR
by Grand Slam-Making Faces, by Lyphard

Ball Four was foaled in Kentucky on February 27, 2001. Four of his wins came in stakes races—three of them graded stakes. In 2006, as a five-year-old, he won the Kentucky Cup Classic Stakes (G2) at Turfway Park. He also finished second in the race in 2005. Then, in 2006, he won the Tejano Run Stakes at Turfway Park. In 2009, he won the Fayette Stakes (G3) at Keeneland, and in 2010, he won the Mervyn Leroy Handicap (G2) at Hollywood Park.

When he retired on March 5, 2011, he had raced thirty-one times and had nine wins, three seconds, four thirds and $730,470 in earnings.[209] He was then sent to Old Friends in Georgetown to enjoy his retirement, and when Kentucky Downs opened, he was sent there.

SGT. BERT
BY CONFIDE-ANOTHER GOOD THING, BY CRAFT PROSPECTOR

Sgt. Bert was foaled in Kentucky on February 8, 2001. The bay gelding's biggest wins came in 2005 and 2006, when he won back-to-back runnings of the Woodford Stakes at Keeneland. In the 2006 running, he set a track record for the 5-1/2-furlong sprint. Upon retirement, he had six wins, eight seconds, five thirds and $359,021 in earnings in forty career starts.[210]

In September 2009, he came to Old Friends in Georgetown courtesy of his owners. Then, in January 2016, he was sent to Kentucky Downs to be one of the first horses at the facility.

TOUR OF THE CAT
BY TOUR D'OR-TUNE IN TO THE CAT, BY TUNERUP

Foaled in Florida on May 3, 1998, Tour of the Cat ran in seventy-nine races and earned $1,106,955. During his career, he won ten stakes races, and when he retired, he had twenty-one wins, thirteen seconds and thirteen thirds.[211]

Tour of the Cat, a ten-time stakes winner, was one of the first horses at Old Friends at Kentucky Downs. *Courtesy of author.*

When he first arrived at Old Friends, he spent some time at Dr. Byars's farm in Georgetown before moving to the main farm. Then, in 2016, he was one of the first horses to be sent to Kentucky Downs.

Hussonfirst
by Hussonet-Bo Bos Sister, by Talc

Hussonfirst was foaled on April 11, 2005, in New York. His racing career did not last long, as he was injured as a three-year-old and retired. In total, he had one win, two seconds, one third and $58,610 in earnings in seven career starts.

In May 2008, he was retired to Old Friends. The loveable chestnut gelding was then sent to Kentucky Downs in January 2016.[212]

Lusty Latin
by El Prado (Ire.)-Scarlet Ann, by Afleet

Lusty Latin was foaled in California on March 26, 1999. He raced fifty times in his career and won six times, was second six times and third nine times and earned $439,729,

One of his biggest wins came as a three-year-old when he won the 2002 Rattlesnake Handicap at Turfway Park. That same year, he finished third in the Santa Anita Derby (G1) at Santa Anita.

The beautiful gray Thoroughbred's final race came in June 2008. He was then donated to Old Friends in Georgetown before being moved to Kentucky Downs in January 2016.[213]

In early 2017, both Hussonfirst and Lusty Latin were moved back to the Georgetown farm.

Dueling Alex
by Meaglia D'Oro-Roie Dooley, by Trempolino

Dueling Alex was one of the first horses retired straight to the Kentucky Downs facility.

Foaled in Kentucky on May 10, 2006, he mostly ran in claiming and allowance races. His final race was a $10,000 claiming race at Keeneland on October 7, 2012. He ended his career with four wins, five seconds, five thirds and $178,655 in earnings in twenty-seven starts.

In January 2016, he was retired to Old Friends at Kentucky Downs, where he lives today.[214]

———

One of the goals for the Kentucky Downs facility is to have horses that won at the track or ran at the track showcased for the tracks' fans. One of those is Good Lord, one of the newer arrivals. By Greatness-Dowager Lady, by Whadjathink, he won the Kentucky Downs Turf Dash at Kentucky Downs in 2012 during his career.

Another newer arrival is Balance of Power. By Silver Train-Wooman's Dancer, by Woodman, his win came in his final race in 2014, when, as a four-year-old, he won the Phillip H. Iselin Stakes (G3) at Monmouth Park for his first and only stakes victory.

FONZI: OLD FRIENDS KENTUCKY DOWNS MASCOT

One final retiree who now calls Old Friends at Kentucky Downs home is Fonzi, a cute miniature horse who has become the farm's mascot.

According to Fonzi's Facebook page, Fonzi came from a loving family in Ohio. Jim Benton, owner of the Thoroughbred breeding farm in Bethel, explained:

About 17 years ago my daughter Sarah was in middle school and wanted a mini....A friend of mine was in the mini business and was going to a sale, so I asked him to buy me a mare in foal. He bought one, but turns out she wasn't in foal, so we bred her to his stallion, and the result was Fonzi...who was foaled in 1998 and was immediately spoiled by the Benton girls....Years later, when the kids grew up and moved away... Fonzi wasn't getting too much attention....When I heard Old Friends was looking for a mini for its Kentucky Downs location, I thought what a great place for Fonzi. I hope he brings joy to many people![215]

PEOPLE OF OLD FRIENDS

*I*t's the start of a new day at Old Friends. Autumn has arrived. The sun is rising, the air is cool and crisp and a light breeze is blowing some leaves around outside the big barn.

A new workday has begun, and some of the farm's current workers—Antonio Marin, James Crump and Tammy Crump—are doing their chores. Some are feeding the horses, others are preparing special mixtures of grain for some of the other horses and others are loading hay onto the back of a Kubota and getting ready to bring it to the horses on the farm.

No question, it takes many people to keep Old Friends running smoothly, and it shows, as everyone knows their job and goes about their chores. Still, if you ask any one of the workers, what they are doing isn't really work. They love what they're doing because they love the horses.

When it comes to getting things done at Old Friends, it all starts with Michael Blowen, of course. Without him, there would be no Old Friends. But after Michael, there are a few other key people on the farm who help get things done.

———

Tim Wilson, Old Friends' farm manager, was born and raised in the Lexington, Kentucky area and is charged with the duty of taking care of the horses, which he has done exceptionally well since he assumed his management position in January 2004.

"Michael and I met because of racing, and he came to one of our races," said Tim. "So, we got to know each other there. Then we did a video series [about Old Friends] together. That was my first really big introduction to Old Friends and the horses and the program and all that. That's where we got together. That's how we met....Then in January 2014 when he was looking for somebody to make a change [and manage the farm], he called me up, and that's it. Pretty simple."[216]

In terms of the horses at Old Friends in his care, Tim knows every single one of them. He knows their names, their history, their health information—everything about every one of them. Each is special to him and gets a lot of attention.

Each day, he hops on a Kubota and drives around the farm at least twice and checks every horse. Almost always they are all doing well and just grazing or napping in their paddocks. But if something is not right with a horse, Tim checks the horse out and makes a determination if it is something that will just take a little care or if a vet has to be called.

"What is very important to me, on a daily basis, is that any owner or trainer of a racing Thoroughbred (no matter how famous or not) be able to have rock-solid confidence that the mainstream medical and husbandry care that their horse receives at Old Friends rises to the exact same high

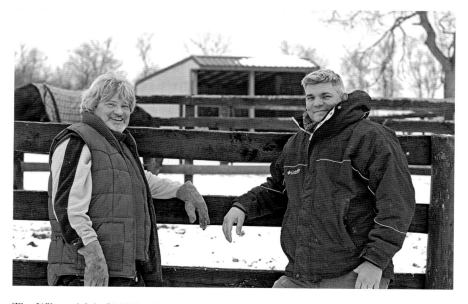

Tim Wilson, *left*, is Old Friends' farm manager, and his brother, Nick, is a volunteer and tour guide at the farm. *Courtesy of author.*

industry standard that horses at other Thoroughbred farms in the region enjoy," said Tim in a paper he wrote. "There is no difference or ambiguity. In other words, any Thoroughbred owner or trainer should be able to walk onto Old Friends and have everything feel very familiar and supportive. Any horse (no matter how famous or not) they retire to Old Friends will be professionally cared for in the manner in which they are accustomed, and any money they invest in the farm will be well spent and intended. Donors (no matter how large) can have full confidence in that."[217]

When Tim arrived at Old Friends, he quickly realized he could not do it all himself. It took some time, but Tim put together a great staff, and everything has been running smoothly.

Every manager, no matter what job, needs a great assistant. In Tim's case, when he arrived at Old Friends, he quickly realized he could not do it all himself, so he put together a really good group to work with the horses. They include assistant managers Carole Oates and Antonio Marin.

Carole was born and raised in New Jersey. "I'm a Jersey girl," she said.[218] She really doesn't know exactly why or how she came to love horses, but in some ways, she believes she was born with a love for them. "My family aren't horse people, and for some reason, when I was around four, we used to go camping, and all I did was hang out with the horses," she said. "We don't know where it came from. So, it was almost like I was born with it [a love of horses]."

When she got out of high school, she went to a school similar to the Kentucky Equine Management Internship (KEMI) program in Kentucky and learned about breeding and stable management of warmbloods. Then, in her twenties, her parents bought a small farm in New Jersey, and she ran it, while also working at the local track at the same time.

While she worked with Standardbreds at the track and worked with some of the top trainers in that industry, she also got involved with Thoroughbreds because of her dad, William Kircher. "My dad got me involved in Thoroughbred racing," she said. "Him and my uncle used to take me to Atlantic City racecourse years ago when I was a little kid. And my idol was Julie Krone. So I used to go down and watch her ride. It was probably almost every weekend. So that got me involved in the Thoroughbred racing world."[219]

As to how she got to Kentucky and Old Friends, well, it was a journey that included getting married to her husband, Roger, in 1998; moving to

Maryland; and teaching fifth grade for eleven years, along with some other things. But the horse bug came back to bite her, as they say, and soon horses were in her life once again. While working at Hagyard Equine Medical Institute, she heard about the assistant managing job opening up at Old Friends. She applied and got the job.

For Carole, working at Old Friends is a blessing each and every day. "Just waking up every morning and not dreading going to work," she said. "I wake up in the morning, and I wonder how so and so [horse] is…or how this horse is. Or what's going to crack me up today. Or what do I want to take a picture of because I'm constantly looking because…Kentucky is beautiful and the horses just make it a hundred percent better.…In the mornings, I enjoy the peacefulness of the farm. The horses are just finishing their breakfasts…and they're enjoying life. It's so relaxing. You just [realize]…'Wow, this is the life.'"[220]

Someone with one of the most important roles at Old Friends is equine veterinarian Dr. Bryan Waldridge.

Dr. Waldridge had, in a sense, the unenviable task of trying to become Old Friends' equine veterinarian following the passing of Dr. Doug Byars, the beloved first vet who took care of the horses on the farm. "I knew Dr. Byars," Dr. Waldridge said. "Well, I knew who he was, of course. I've been to some of his talks. And then I interviewed for a job at Hagyards, and that's where we kind of first really met each other. Then we just kind of stayed in touch a little bit after that."[221]

No question that Dr. Waldridge has some great veterinarian credentials of his own, and once he started to come out to Old Friends to care for the horses, he, like so many before, just came to love them. He came out whenever called or on his own if he just wanted to check on a horse under his care. And not once has he ever sent a single bill to Old Friends.

With his hard work and devotion, he quickly earned Michael's respect and was accepted by everyone as part of the Old Friends family. So, making the decision to work with Old Friends was easy. He explained:

> *I think you should give back. You know, I've made my living off of horses for most of my career, so I just feel like you ought to give back. When I came out here that first time, I thought about it and I thought, "You know, that would be kind of fun to do."*

So, I thought about it some more and talked to Michael, [and] *he eased me in. He tested me out there for a while, and it was just enjoyable. The people here are awesome. You can't beat the people. Everybody cares. And the horses, well, they need help, some of them. So, you want to help them out. I like the old horses, and I like* [the ones that] *nobody knows….It's just really cool and a lot of fun.*[222]

As to whether he has a favorite horse, he said:

It's fun to work on these famous ones. It's always cool to see a horse that you saw, like Game On Dude. I remember setting the timer on my phone [while] *working in the yard to come in and watch him run in the Dubai World Cup. You think, I'll never work on that horse. And, then, here he is. He's one of my favorites. It's just cool.*[223]

———————

There are also some other people who have done a lot for Old Friends and need to be mentioned.

The first is Lord Nicholas Newman, or Nick to his friends and associates. Nick is Tim Wilson's brother and was born and raised in Lexington, Kentucky. He has worked full time as a firefighter for the Lexington (Kentucky) Fire Department for twelve years. He is a first responder.

So, how did he get the title of "Lord," you might be wondering? "I am the title holder of ancestral land in Scotland," said Nick. "Owning land in Scotland entitles the holder to the Nobility title of Lord."[224]

Nick also loves horses and has worked for some of the local horse farm tours in the area, which is how he found Old Friends. "Most firefighters have part-time jobs, and given my lifelong love of horse racing, guided tours for Thoroughbred Heritage Farm Tours was a natural fit," he said.[225]

Today, he also gives tours of Old Friends in his spare time and helps his brother out with things that need to be done on the farm.

One of the first horses Nick really liked at Old Friends was Ballindaggin, a multiple stakes winner who won four races in fourteen career starts. However, in those four wins, he swept the 1987 New York Stallion Series and the 1988 Molson Export Challenge.[226] "Ballindaggin and I developed a relationship and a bond during my tenure as an outside tour guide," said Nick. "His passing hit me much harder than I expected. So, after he died, I decided to commit myself to helping the farm any way I could."[227]

If you are ever at Old Friends, especially on weekends, you will usually find Nick out giving some of the tours.

———————

Another person who is not at the farm but has done tremendous work in helping Old Friends raise funds is Sally Faith Steinmann. Sally lives in Cape Cod with her husband, Tom, who is an artist, and her beloved cat, Marmee. "I was born on Cape Cod, and except for the years I attended Wellesley College, this has always been my home," said Sally. "I'm a real Cape Cod girl!"[228]

One of the many special things about Sally is her love for her cats; first Maggie Mae, which she named her business after, and her second cat, Marmee. "Maggie Mae was my first kitty, a gorgeous tiger tabby I got from a local rescue," she said. "I named my business, Maggie Mae Designs®, after her and she was my muse for over fourteen years. Sadly, Maggie died several years ago of diabetes....We found Marmee soon thereafter at the same local rescue. Marmee is such a love. All she wants to do is connect, and she loves it when I photograph her."[229]

As to her professional life, Sally creates hats full time for her own business, Maggie Mae Designs®—beautiful hats that people buy to wear at big-time social events, such as the Kentucky Derby, Breeders' Cup, Royal Ascot in England and more. "I started making hats for ladies attending horse races like the Kentucky Derby and Royal Ascot almost from the start," she said. "I was a total horse nut as a little girl, and my family watched the Triple Crown races every year without fail."[230]

She continued: "Over the years, more and more women who were attending equine sporting events began to find me as they searched for the perfect Derby chapeau. Many of these women were devout horse lovers just like me, so we'd talk hats and horses. I was in heaven! In the very best of ways, my passion for hats was leading me full circle back around to my very earliest of childhood passions: the horses."[231]

Sally has loved horses her whole life and began featuring hats for the Kentucky Derby, Royal Ascot and other big races each year. However, over the years, she saw great racehorses like Ruffian and Go for Wand suffer life-ending injuries. She also learned that not all racehorses have happy endings. Because of that, she wanted to do more.

In 2007, she created a hat to honor Barbaro, and in 2009, she created one to honor the Eight Belles Memorial Fund. She also created one to

Sally Faith Steinmann has raised money for Old Friends with her hat designs. Here she sits with her beloved cat, Marmee. *Courtesy of Sally Faith Steinmann.*

celebrate Rachel Alexandra for the Kentucky Derby Museum's Annual Hat Contest Exhibit.[232]

In time, she learned about Michal Blowen and Old Friends. "Michael's love and respect for the horses in his care are evident in his every word and action, and his dream for the farm is really coming true," said Sally. "Old Friends is indeed a haven for the retired racehorses living there and a marvelous outreach for educating the public about the needs of all horses."[233]

So, Sally began creating and donating custom Derby hats to Old Friends and auctioning them off to raise money for the horses on the farm. This year (2017) will be her eighth year helping Old Friends.

Sally has also started two new hat lines to benefit Old Friends. In 2014, she started the Rosie Signature Hat Collection, named after former jockey Rosie Napravnik, who had modeled some of Sally's Old Friends hats. Then, in 2015, she launched the Little Silver Charm Kids' Hat Collection, which was named for Little Silver Charm, Old Friends' SpokesHorse.[234]

Sally is one of those quiet Old Friends heroes. She's helped the farm raise thousands of dollars over the years with her beautiful hat creations and is someone Michael is very grateful to have in the Old Friends family.

———

Two other people who have to be mentioned for their help and support of Old Friends are Ercel Ellis and his wife, Jackie Ellis. Ercel is in his mid-eighties, stands about five-foot-ten and has a personality that lights up any room he walks into.

He has worked in Thoroughbred horse racing for what seems like forever. He worked at the *Daily Racing Form* when its offices were located at Keeneland, at *Blood-Horse* magazine and at his own equine ad agency.

He is also a walking encyclopedia of Thoroughbred racing and pedigree knowledge. Ask him a question about a stallion from any year, and he'll most probably be able to tell you anything you want to know about it: pedigree, race record, stud record—you name it, he usually knows it off the top of his head.

His all-time favorite horse is Man O'War, whom he saw race and saw at stud. He also attended the great horse's funeral with his dad. Ask him about Man O'War and then just settle back and listen to his stories. They are very enjoyable.

Over the years, Ercel has also hosted two radio programs. One was a daily racing recap show, which he did for more than fifty years, and the other, which is still on today, is called *Horse Tales with Ercel Ellis*. Every Saturday morning on his show, currently on 105.5 FM in Lexington, he talks about horses and the past week's races. He also talks about historic horses. But the highlight each week is the guests he has on the show. People in the industry, current and past, come to tell stories about the farms, the backstretches at the tracks and more. If you are a horse racing fan, you don't want to miss this show.

Ercel had Michael on the show a few years before Old Friends opened. At the time, Michael worked at the Thoroughbred Retirement Foundation, and he'd come on and talk about the horses at the foundation. He said of the program:

> *I first went on his show before Old Friends was started when I was the operations director for the Thoroughbred Retirement Foundation. And I think it's made a tremendous difference* [going on the show]. *It's like*

you're getting the Pope's blessing to go ahead and what you're doing is not totally insane. That it might work.

Then, as time has gone on, of course, the people that come on the show that I get to meet, and people that listen to the program, are always stopping me and telling me they really like the show and love Ercel. It takes a special kind of person to do that program, and he certainly does it because he's probably the most knowledgeable horse person I know. That's always helpful because when he comes to the farm and sees the horses, he knows what he's looking at.[235]

When Michael was first starting Old Friends, he felt that Ercel was one of the first people who really believed in what he was trying to accomplish. "When I first started going on Ercel's show, he was very concerned about aftercare," said Michael. "He was one of the real leaders in finding places for these horses."[236]

In an interview while sitting with his wife, Jackie, in the kitchen of their home on their beautiful farm in Bourbon County, Ercel deflected Michael's kind words by adding:

You know, there were a lot of people that pensioned out the old horses. I know when my dad, Ercel F. Ellis, was managing Dixiana [Farm in Lexington]…we had old horses turned out on the farm at that time. In fact, one of the original broodmares, Miss Jemima, was a foal in 1917, and she was a foundation mare they brought here from Colonel E.R. Bradley [Edward R. Bradley]. I was just a kid and she was retired and my job was cleaning her stall. I was eight, nine years old going to take care of Miss Jemima….But there were a lot of people that cared about their old horses at that time.[237]

Still, at first, while Ercel liked Michael, and they have become good friends over the years, he was a little skeptical about Michael's idea about Old Friends. "We [with his wife, Jackie] thought at the time that it was a screwy idea—Old Friends," said Ercel. "He'll never make this work. It's a screwy idea."[238]

But one thing that Ercel adamantly states proudly now about Michael and Old Friends is that "he made it work." Ercel believes that Michael saw a "hole" in the industry with these old racehorses—stallions in particular—and he filled that hole to great success:

> *Michael saw the hole because stallions are hard to take care of. They each have to have their own paddock, and they're famous and they bring tourists—boom! What everybody, I think, underestimated in the business was the popularity of some of these old horses. And people come from, right now, to Old Friends, from all over the world to look at a particular horse. Michael knew that—how he knew that and, for the rest of us, it went right over our heads—I don't know.*[239]

Slowly, after his first appearances on the show, Michael became a regular, and the two friends banter back and forth each week about everything and anything in horse racing and, of course, about Old Friends. The running joke between the two is how, every week, Michael finds a new way to ask for donations for the farm. One time, Michael even got Ercel to make a big donation by accident. Ercel explained:

> *They had a birthday party for me down there at The Black Tulip* [in Midway]. *I didn't know it was my birthday party. They said, "Come on down," you know. So, we* [Ercel and his wife, Jackie] *went to The Black Tulip, and of course, the food was great there.*
>
> *I walked in and there's "the jar"—you know, where people drop money* [for donations to Old Friends]. *And I wrote a check for a hundred bucks and put it in.*
>
> *It turned out to be my surprise birthday party. I've been on him ever since for charging me $100 to go to my own birthday party.*[240]

Michael fervently believes that Ercel having him on the show each week has helped Old Friends become so successful. "He's a great friend," said Michael. "Ercel's a magnet for really good people. And I think that's one of the things that's made the show successful. Obviously, the show itself has survived all these years. He's got really loyal advertisers....But, he's just exposed Old Friends to an audience that we really, really needed. An audience where we really needed their support."

Of course, Ercel and Jackie like Michael and Diane a lot, and they believe that what Michael is doing is important for the horses as well. Plus, they like Michael and Diane personally, and they have become good friends over the years.

"Yeah, and we *love* Diane," added Jackie, with a smile.[241] Jackie believes that Michael's enthusiasm and drive are what made Old Friends successful. Plus, she added, "He had that pony in his backyard. It used to come up on

the deck and bang on the door. You've got to love somebody that has a pony in the backyard."

The "pony" she's referring to is Little Silver Charm. When Michael and Diane first moved to Kentucky, they lived in Midway and kept Little Silver Charm in their yard. The little horse would come up on the house deck and knock on the door with his hoof. Michael would let him in, and he'd wander around the house and then join Michael in the den and "watch" TV. When he wanted to leave, he'd go back to the front door and bang on it. Michael would get up and let him out, and he'd go back to grazing in the yard.

As time moved forward, Michael kept being invited onto Ercel's show until he just became a regular. "I thought he was just a good part of the show," said Ercel. "I mean, he's always fun to talk to. I love to needle him."

These few people talked about here are just the "tip of the iceberg" of all those who have helped make Old Friends such a success. There are so many more. Michael, the horses and everyone at Old Friends are very thankful and grateful to each and every one of them. You know who you are!

Chapter 22

OUT OF THE ASHES

*M*ichael! Michael! The barn's on fire!"

Those were the first loud, panicked screams that Michael Blowen heard near dawn on Saturday, January 23, 2016. It was a brutally cold day following what Michael called "one of the worst snowstorms he's seen since he moved to Kentucky."[242]

The words came from Tammy Crump, whose husband, James Crump, works on the farm. Tammy helps out, too.

It turns out that the small, old wooden medical barn on the farm was engulfed in flames. Michael explained:

> *It's like seven o'clock in the morning on that Saturday, and I hear the door swing open and I hear this scream from Tammy: "Michael. Michael. There's a fire in the barn! There's a fire in the barn!" So, I throw on my clothes and I get out there. I'm out there in like three minutes, maybe four minutes, and the barn is completely engulfed already. Flames flying.*
>
> *Thankfully, they* [the two horses] *were out, they were safe—that's what mattered. But then it started sinking in as the flames got higher and higher, and hotter and hotter—holy mackerel! I was never around fire before. I didn't think of it one way or another, except pour water on it and it stops. Well, that's really not what happens. That thing turned into an inferno within minutes.*[243]

Because of the fire that day, Michael was determined to build the best, most fireproof barn as soon as possible.

Tammy and James came to the farm together, but with different backgrounds. Tammy, who is originally from Massachusetts, has been working around the farm since 2015. Prior to coming to Old Friends, she had never really been around horses, though. "I've never fooled with a horse a day in my life until I volunteered out here at Old Friends," she said. "I never, ever fooled with a horse. And now I live it. I love it."[244]

What she loves most about the farm is "the peace and quiet, and the horses and just doing whatever we want to do," she said. "We're not stressed, we're not pressured, just doing whatever. We see what needs to be done and go do it.…The horses are the best part. Because you learn which one has a bad attitude, which one's not good, and I enjoy it. I love it. I wouldn't change it. Little Silver's my buddy. He doesn't try to bite."

James, who was born in Kentucky, lived in Eustis, Florida, for about nineteen or twenty years. It was there that he got involved with horses for the first time by a friend. "When I was going to middle school and high school, I had a friend in Eustis, Florida," he said. "Her and her brother had some Thoroughbred horses. So, I'd go there and help her bathe them and clean stalls and mow pastures and things like that."

James moved back to Kentucky in 1998, and in 2015, he found his way to Old Friends and began working for Tim at the farm doing whatever was needed. "From bathing and helping with the horses to mowing to tearing tractors apart," he said.

Like Tammy, the peacefulness is one of his favorite parts about Old Friends. "The tranquility of it all," he said. "The peace and quiet and knowing that you have a task to do and try to get it done."[245]

Of course, that tranquility took a bit of a turn that January morning. Originally, Tammy and James were not even supposed to be at Old Friends that Saturday. But because of the impending snowstorm, they decided to stay overnight. "It was going to snow that night, and we figured, well, we'll just stay," said Tammy. "So, we set up a room [in the little house next door], and we stayed the night. But it was supposed to be his [James's] day off the next morning, but we figured we're here, we might as well go up [to the main farm]."[246]

Because of that bit of luck, the fire was discovered early enough to save the horses. "We started up [riding a Kubota over to the main farm]," she said, "and there was snow all over the place. The wind was blowing, and I

looked over at the small barn and said, 'Is that smoke?'" James said it was just snow blowing off the roof.

Then, as they got closer, they both realized it was smoke, and when they pulled up to the barn, they could see that the hay in the barn was on fire. They also noticed Tim's car, and the first thing James started to do was yell for Tim, whom they thought had stayed the night in the little room in the barn. But Tim was not there.[247]

It turned out that on Friday night, Dr. Waldridge, Tim, Michael and Antonio (a farm worker) were in the barn and Game On Dude had coliced. They had to get him to the hospital. They tried to call one of the horse van companies, but they were all closed because of the weather. Plus, the police were saying stay off the roads. But they had to get Game On Dude to the clinic. Said Dr. Waldridge, "We've got to go."[248]

"So, we got our little trailer hooked up, they got Game On Dude on the trailer and Tim rode in the back of that trailer with the horse [to Park Equine Hospital, where Dr. Waldridge works]," said Michael. "It took nearly an hour to get [to the hospital in that weather]....Tim stayed with Game On Dude all night; he slept on the floor in Dr. Waldridge's office, and everything worked out great. They were able to treat Game On Dude's colic episode without surgery. He was doing great. Tim was doing great. He had stayed with Game On Dude the entire night; he wouldn't leave his side. Such is his devotion to the horses at Old Friends."[249]

So, once Tammy and James realized Tim was not there, the two got to work to save the two horses inside the barn—Alphabet Soup and Archie's Echo—and to alert Michael to what was going on. Thanks to a little luck, they got them out, but not without a little drama. James explained:

Well, the one good thing is they both had their halters on them that night. I mean, most times whenever they come in, we take their halters off. But for some reason, both of them had their halters on. I do remember not having to put their halters on.

...The place was smoking up real good. So, I hooked the shank to Alphabet, and I [got him out]. Alphabet Soup was placed in the round pen between the main barn and the small one where the fire raged. There he just casually began grazing, not a care in the world.[250]

As for Archie's Echo, he was a little harder to coax out, as James explained:

I went back for Archie and I put the shank on him…and I got him right up to the stall door, and he just started wanting to back up and raising his head. And, I told him, "Come on, Archie, we've got to go, buddy. We can't stay here. We have to go!"

So, I pulled on him some more, and he took one step out, and then he stopped again and he just pulled his head back you know. I said, "God damn it, Archie…we've got to get out of here." [Again] I pulled the shank back, acting like I was going to hit him with the other end, and he just turned to the side and he just wouldn't go. So, I tapped him a little bit some with the shank, cussed at him some more and tugged, and finally he started his motion of coming [forward].

It seemed like it took me over five minutes to walk him from out of the end of that barn, down and around to get him to the stall [in the big barn]. I mean, by the time I got Archie into the barn and put him beside Wallenda and walked out, the barn had burned almost up to the next stall beside Archie's. It took me that long to get him [out and] around.[251]

"If we wouldn't have been here…well, it's a blessing that we were here," said Tammy, still a little choked up about the fire and getting those horses out months later.[252]

While everyone was relieved the fire was out and that no horses or humans were injured, there was still a sadness in the air. "We had recently finished painting the barn," said Tammy. "Plus, we had all the paddock signs hanging along the rafters of the Old Friends horses that had passed away. We stood there and just cried. Me and him [James], we lost it because there was a lot of time and effort into that place. It was so much work. Me and him painted the outside with just rollers and brushes. There was no spraying it. It was manual hand."[253]

Added Michael, "What we lost is a lot of great memories, and we lost those kinds of things, and we lost the barn and we had to build a new barn, etc. Still, Tim was devastated because he wasn't there.…It was a terrible day…a terrible several days."[254]

But, as they say, "out of the ashes," good things happen. What amazed Michael was the amount of support that came from all around the horse racing community. Within a few days, thousands of dollars had been donated to help rebuild the barn. The biggest, $50,000, came from Fasig-Tipton, the auction house. Its only request was, if possible, to name the new barn after John Hettinger, which Michael was happy to do.[255]

According to Michael, "John was one of the most successful, progressive breeders in American racing. He ran Akindale Farm in New York, which he bequeathed to aftercare. I remember many summer mornings sitting on his porch in Saratoga ruminating over the future of Thoroughbreds once their racing and breeding careers were over. And he was a man of his word. If he told you something, you didn't even need a handshake to seal the deal."[256]

More money came in, and soon the new barn was complete and the farm was holding its grand opening. Ercel Ellis even broadcast his show from the new barn that day.

Michael rightfully calls the new barn "state-of-the-art"—ten times better and much bigger than the old one. It contains ten stalls, two of which are double-sized; a storage room; an office; and a bath area for the horses reachable from either inside or outside. All of the stalls have big windows to the outside so the horses can stick their heads out and see everything going on. And on one side, the stalls have doors so that horses in the barn have access to paddocks and can come and go as they please.

Most important of all, the material used to build the barn is 99 percent fireproof. In addition, the builders buried all the wires, which have been identified as the probable source of the fire (with rodents chewing on them). "With this new barn…it's as fire-safe as we can make it without making it with concrete," said Michael. "We're doing the best we can, and the fire chief has approved it."[257]

Chapter 23

CATCHING UP WITH
LITTLE SILVER CHARM

*I*n the first book about Old Friends, the story of how Little Silver Charm came to live with Michael and Diane was told.

Since then, Little Silver Charm's legend has only grown. Booted from his paddock by a pair of goats (Google and Yahoo) and a Breeders' Cup champ (Eldaafer), the little guy has a brand-new paddock, two books written about his life, some personal hairstylists, a Facebook page and a Twitter feed with hundreds of followers. And that's just a few things he has going for him these days.

In addition, he is still the official SpokesHorse of Old Friends, a position he takes very seriously. Recently, he spent time with his personal secretary, Diane (Michael's wife), to dictate a personal message to all of you:

This is a personal message from me, Little Silver Charm, to all my friends and fans.

I thought you might like to know more about how I founded Old Friends.

Michael owes me an enormous debt of gratitude. I made this place. But does he ever acknowledge my crucial role in starting Old Friends?

All I ever hear from him, over and over again, is the story of how he saved me from the slaughter truck. Blah, blah, blah...

But the truth is that I saved him from a meaningless, empty existence and inspired him to do something worthwhile with his life.

Little Silver Charm is the undisputed SpokesHorse at Old Friends. *Courtesy of author.*

I'd also like to bring you up to date with what I've been doing recently. As you know, there's nothing I can't do. Writer. Artist. Muse. SpokesHorse. Confidant of the famous. There is no end to my talents.

My book, A Charmed Life, *now in its third printing, is a best seller in the Old Friends gift shop. I also inspired writer and artist Dan Rhema to write a novel,* Little Silver Charm, *about my fictional exploits as a circus horse. I have been a muse to artists too numerous to list here, who have created paintings, sculpture, photographs and works in various media, all celebrating yours truly.*

Recently I also took on the role of miniature SpokesHorse for the tourism office in Georgetown, Kentucky, where Old Friends is located. My photograph appears on every page of their new brochure along with my advice on where to shop, stay, eat and visit when in Georgetown.

I'm still the hardest working horse on the farm, ever ready to help with tours and public outreach, especially if my efforts are rewarded with carrots and kisses. Ask any horse at Old Friends: Who's the MVP around here? Each and every one will answer: Little Silver Charm. Except for (Big) Silver Charm who is under the illusion that he's the main attraction. He's not, I am.

Epilogue

THE FUTURE IS BRIGHT
FOR OLD FRIENDS

*A*s the sun sets on another day at Old Friends, Silver Charm and Alphabet Soup are tucked away in their stalls in the new barn, while War Emblem grazes peacefully in his paddock because he loves to stay outside.

All around the farm, the other horses are enjoying the quiet as evening draws closer. Some are grazing and others are walking around their paddocks, while others are standing in their run-in sheds getting ready for a good night's sleep.

For these beautiful Thoroughbreds at Old Friends—champions, allowance racers and claimers alike—the peace and serenity of the farm ensures that each one of them will have a peaceful retirement. After all they have given to the sport, to their owners, to their trainers and to their fans, to be able to live out their lives by just "being a horse" is what they deserve. After all, if it wasn't for the horses, there wouldn't be a sport.

Thanks to Michael's creation of Old Friends and his belief that "the horses must come first," he, along with many others, has helped bring Thoroughbred aftercare to the forefront of importance in horse racing. Today, more than ever before, owners, trainers, racetracks and others are working to ensure that the health and welfare of the horses is a top priority.

Not only did Michael's dream come true, but it has also grown beyond his wildest imagination. It is to his credit that many of today's Thoroughbreds—past, present and future—now have a place to live in peace and dignity for the rest of their lives.

NOTES

Chapter 1

1. Interview with Michael Blowen, July 5, 2016.
2. Stats courtesy of PedigreeQuery.com and Brisnet.com.
3. Interview with Michael Blowen, July 5, 2016.
4. Ibid.
5. Ibid.
6. Ibid.
7. Ibid.
8. Steven Haskin, "A Part of History," *Blood-Horse* (May 9, 2015): 25–40, quote pages 26–27.
9. Ibid.

Chapter 2

10. Stats courtesy of PedigreeQuery.com and Brisnet.com.
11. Interview with Chris McCarron, July 9, 2016.
12. Interview with Michael Blowen, June 23, 2016.
13. Ibid.
14. Said during a tour by John Bradley, July 9, 2016.

Chapter 3

15. Interview with Michael Blowen, June 23, 2016.
16. Stats courtesy of PedigreeQuery.com and Brisnet.com.
17. Old Friends website, "War Emblem," www.oldfriendsequine.org/horses/war-emblem-24796.html.

18. Interview with Michael Blowen, July 9, 2016.
19. *Old Friends Newsletter*, February 24, 2016, about War Emblem.
20. Interview with Michael Blowen, June 23, 2016.

Chapter 4

21. Old Friends website, "Sarava," www.oldfriendsequine.org/horses/sarava-4260.html.
22. Equibase, race chart, http://www.equibase.com (look up Sarava under horses).
23. Ibid.
24. Stats courtesy of PedigreeQuery.com and Brisnet.com.

Chapter 5

25. *Paulick Report*, "'Dream Come True': Charismatic Returning Stateside, to Live at Old Friends," press release, October 26, 2016, www.paulickreport.com/horse-care-category/dream-come-true-charismatic-returning-stateside-live-old-friends.
26. Ibid.
27. Stats courtesy of PedigreeQuery.com and Brisnet.com.
28. *Paulick Report*, "Dream Come True."
29. Ibid.
30. Frank Angst, "Lukas Drops By to See Old Friend Charismatic," America's Best Racing, December 5, 2016, https://www.americasbestracing.net/lifestyle/2016-lukas-drops-see-old-friend-charismatic.
31. Old Friends, press release, February 19, 2017.
32. Natalie Voss, "Veterinarian: Only 'Divine Intervention' Could Have Saved Charismatic," *Paulick Report*, February 21, 2017, http://www.paulickreport.com/horse-care-category/vet-topics/veterinarian-divine-intervention-saved-charismatic.
33. Michael Blowen, "Charismatic Obituary," *Special Old Friends Newsletter*, February 21, 2017.

Chapter 6

34. Natalie Voss, "Game On Dude, Amazombie Arrive at Old Friends," *Paulick Report*, October 7, 2014, http://www.paulickreport.com/news/bloodstock/game-on-dude-amazombie-arrive-at-old-friends.
35. Stats courtesy of PedigreeQuery.com and Brisnet.com.
36. Interview with Michael Blowen, June 30, 2016.
37. Ibid.
38. Ibid.

CHAPTER 7

39. Ibid.
40. Stats courtesy of PedigreeQuery.com and Brisnet.com.
41. Old Friends website, "Rapid Redux," www.oldfriendsequine.org/horses/rapid-redux-3687.html.

CHAPTER 8

42. Interview with Michael Blowen, June 23, 2016.
43. Breeders' Cup website, "Alphabet Soup, Breeders' Cup Champion," www.breederscup.com/history/hall-of-champions/horse/3341.
44. Interview with Chris McCarron, July 9, 2016.
45. Breeders' Cup website, "Alphabet Soup, Breeders' Cup Champion."
46. Amy Nesse, "Breeders' Cup Legends: Alphabet Soup," Past the Wire, www.pastthewire.com/breeders-cup-legends-alphabet-soup.
47. Interview with Michael Blowen, June 23, 2016.
48. Nesse, "Breeders' Cup Legends: Alphabet Soup."
49. Ibid.
50. Ibid.
51. BloodHorse.com, "Frank Angst, Alphabet Soup Progressing Under Cancer Treatment," January 9, 2017, www.bloodhorse.com/horse-racing/articles/218943/alphabet-soup-progressing-under-cancer-treatment. A longer article explaining the treatment can be found in Frank Angst, "Promising Cancer Treatment for an Old Friend," BloodHorse.com, October 8, 2016, http://i.bloodhorse.com/pdfs/BH41EquineCancer.pdf.

CHAPTER 9

52. Interview with Michael Blowen, June 23, 2016.
53. Ibid.
54. Ron Mitchell, "Post-Race Fisticuffs Follow BC Marathon," BloodHorse.com, November 6, 2010, http://www.bloodhorse.com/horse-racing/articles/139571/post-race-fisticuffs-follow-bc-marathon.
55. Byron King, "Eldaafer Pulls Away in Breeders' Cup Marathon," *Daily Racing Form*, November 5, 2010, http://www.drf.com/news/eldaafer-pulls-away-breeders%E2%80%99-cup-marathon.
56. Old Friends website, "Eldaafer," http://www.oldfriendsequine.org/horses/eldaafer-19834.html.
57. Stats courtesy of PedigreeQuery.com and Brisnet.com.
58. Old Friends website, "Eldaafer."
59. Interview with Michael Blowen, June 23, 2016.
60. Ibid.
61. Ibid.

CHAPTER 10

62. Old Friends website, "Tinners Way," www.oldfriendsequine.org/horses/tinners-way-3738.html.
63. Stats courtesy of PedigreeQuery.com and Brisnet.com.
64. David Schmitz, "Tinners Way Retired to Old Friends," BloodHorse.com, September 14, 2010, http://www.bloodhorse.com/horse-racing/articles/140422/tinners-way-retired-to-old-friends.

CHAPTER 11

65. BloodHorse.com, "Derby Winner Genuine Risk Dies," August 19, 2008, http://www.bloodhorse.com/horse-racing/articles/152621/derby-winner-genuine-risk-dies.
66. Ibid.
67. Stats courtesy of PedigreeQuery.com and Brisnet.com.
68. BloodHorse.com, "Derby Winner Genuine Risk Dies."
69. Old Friends website, "Genuine Reward," www.oldfriendsequine.org/horses/genuine-reward-25056.html.
70. Interview with Michael Blowen, June 30, 2016.
71. E-mail interview with Laura Hillenbrand, July 16, 2016.
72. Ibid.
73. Interview with Michael Blowen, June 30, 2016.
74. E-mail interview with Laura Hillenbrand, July 16, 2016.
75. Ibid.
76. Ibid.
77. Ibid.

CHAPTER 12

78. Rick Capone, "The Ride of a Lifetime: Louisiana Legend Bonapaw Still Enjoys Life at Old Friends," *American Race Horse* (September/October 2015).
79. Ibid.
80. Ibid.
81. Ibid.
82. Ibid.
83. Ibid.
84. Ibid.
85. Ibid.
86. Ibid.
87. Ibid.
88. Interview with Michael Blowen, June 30, 2016.

Chapter 13

89. Stats courtesy of PedigreeQuery.com and Brisnet.com.

90. Interview with Michael Blowen, July 2016.

91. Ibid.

Chapter 14

92. Maureen Werther, "From the Preakness to the Pasture: Retired Thoroughbred Finds New Home in Greenfield," *Saratogian*, September 10, 2016, www.saratogian.com/article/ST/20160910/NEWS/160919967.

93. Stats courtesy of PedigreeQuery.com and Brisnet.com.

94. Nicole Russo, "King Congie Saved from Slaughterhouse," *Daily Racing Form*, August 22, 2016, www.drf.com/news/king-congie-saved-slaughterhouse.

95. Nicole Russo, "King Congie to Reside at Old Friends at Cabin Creek Farm," *Daily Racing Form*, August 26, 2016, www.drf.com/news/king-congie-reside-old-friends-cabin-creek-farm.

96. Ibid.

97. For information on Rosemary Acres, go to http://rosemaryfarm.org.

98. Werther, "From the Preakness to the Pasture."

99. Ibid.

100. Ibid.

101. Ibid.

Chapter 15

102. Old Friends website, "Thornfield," www.oldfriendsequine.org/horses/thornfield-596.html.

103. Stats courtesy of PedigreeQuery.com and Brisnet.com.

104. Old Friends website, "Benburb," www.oldfriendsequine.org/articles/benburb-1989--2012.html.

105. Ibid.

106. A great story about Benburb's win in the 1992 Queen's Plate can be found on the Fort Erie Race Track website at http://www.forterieracing.com/about-us1/our-history.

107. Ibid.

108. Stats courtesy of PedigreeQuery.com and Brisnet.com.

109. Ibid.

110. Ibid.

CHAPTER 16

111. Stats courtesy of PedigreeQuery.com and Brisnet.com.
112. Susan Salk, "One-Eyed T'Bred Rescued by Parx VP and Friends," *Off Track Thoroughbreds*, June 22, 2015, http://offtrackthoroughbreds.com/2015/06/22/one-eyed-tbred-rescued-by-parx-vp-and-friends.
113. Karen M. Johnson, "2001: The Year of Say Florida Sandy," *Daily Racing Form*, April 5, 2002, http://www.drf.com/news/2001-year-say-florida-sandy.
114. Ibid.
115. Stats courtesy of PedigreeQuery.com and Brisnet.com.
116. Ibid.
117. Handwritten story by Carole Oates and given to author in June 2016.
118. Stats courtesy of PedigreeQuery.com and Brisnet.com.
119. E-mail interview with Vivian Morrison, January 2017.
120. Stats courtesy of PedigreeQuery.com and Brisnet.com.
121. E-mail interview with Lorita Lindemann, December 12, 2016.
122. Stats courtesy of PedigreeQuery.com and Brisnet.com.
123. Ibid.
124. Ibid.
125. E-mail interview with Laura Battles, January 27, 2017.

CHAPTER 17

126. Stats courtesy of PedigreeQuery.com and Brisnet.com.
127. Ibid.
128. Interview with Charles Nuckols, August 4, 2016.
129. Ibid.
130. Ibid.
131. E-mail interview with Don Veronneau, June 2, 2016.
132. Ibid.
133. Stats courtesy of PedigreeQuery.com and Brisnet.com.
134. Old Friends website, "Mixed Pleasure," http://www.oldfriendsequine.org/horses/mixed-pleasure-4329.html.
135. Ibid.
136. E-mail interview with John Bradley, August 3, 2017.
137. E-mail interview with John Bradley, September 30, 2016.
138. Stats courtesy of PedigreeQuery.com and Brisnet.com.
139. Old Friends website, "Sea Native," http://www.oldfriendsequine.org/horses/sea-native-592.html.
140. Secretariat Festival, www.secretariat.com/fan-club/disney-film-news/disney-coming-to-secretariat-festival.
141. Old Friends website, "Sea Native."
142. E-mail interview with Angela Black, July 6, 2016.

143. Old Friends website, "Sea Native."
144. Old Friends website, "Hidden Lake," www.oldfriendsequine.org/horses/hidden-lake-559.html.
145. Stats courtesy of PedigreeQuery.com and Brisnet.com.
146. Old Friends website, "Hidden Lake."
147. Ibid.
148. Old Friends website, "Wallenda," www.oldfriendsequine.org/horses/wallenda-32.html.
149. Ibid.
150. Stats courtesy of PedigreeQuery.com and Brisnet.com.
151. Old Friends website, "Wallenda."
152. Ibid.
153. Ibid.
154. Interview with Tim Wilson, February 14, 2017.
155. Stats courtesy of PedigreeQuery.com and Brisnet.com.
156. Old Friends website, "Gulch," www.oldfriendsequine.org/horses/gulch-637.html.
157. Ibid.
158. Ibid.
159. Ibid.
160. E-mail granting permission to use from Laura Hillenbrand, July 1, 2016. Her essay is on her Facebook page.

CHAPTER 18

161. New York Thoroughbred Breeders Inc., "Be Bullish Claimed by Repole, Retired to Old Friends Cabin Creek a Winner," www.nytbreeders.org/news/2015/05/18/be-bullish-claimed-by-repole-retired-to-old-friends-cabin-creek-a-winner.
162. Stats courtesy of PedigreeQuery.com and Brisnet.com.
163. Ibid.
164. Old Friends website, www.oldfriendsatcabincreek.com/our-horses/current-residents, then look for the horse.
165. Old Friends website, "Commentator," www.oldfriendsequine.org/horses/commentator-560.html.
166. Stats courtesy of PedigreeQuery.com and Brisnet.com.
167. Ibid.
168. Old Friends website, www.oldfriendsatcabincreek.com/our-horses/current-residents, then look for the horse.
169. Stats courtesy of PedigreeQuery.com and Brisnet.com.
170. Old Friends website, www.oldfriendsatcabincreek.com/our-horses/current-residents, then look for the horse.
171. Ibid.
172. Ibid.

173. Ibid.
174. Stats courtesy of PedigreeQuery.com and Brisnet.com.
175. Stats courtesy of the Equibase.com race chart.
176. Old Friends website, www.oldfriendsatcabincreek.com/our-horses/current-residents, then look for the horse.
177. Ibid.
178. Stats courtesy of PedigreeQuery.com and Brisnet.com.
179. Old Friends website, www.oldfriendsatcabincreek.com/our-horses/current-residents, then look for the horse.
180. Stats courtesy of PedigreeQuery.com and Brisnet.com.
181. Old Friends website, www.oldfriendsatcabincreek.com/our-horses/current-residents, then look for the horse.
182. Stats courtesy of PedigreeQuery.com and Brisnet.com.
183. Old Friends website, www.oldfriendsatcabincreek.com/our-horses/current-residents, then look for the horse.
184. Ibid.
185. Stats courtesy of PedigreeQuery.com and Brisnet.com.
186. Ibid.
187. Old Friends website, www.oldfriendsatcabincreek.com/our-horses/current-residents, then look for the horse.
188. Ibid.
189. Ibid.
190. Interview with Michael Blowen, June 30, 2016.

CHAPTER 19

191. *Paulick Report*, "1992 Travers Winner Thunder Rumble Dies at 26," press release, January 7, 2015, www.paulickreport.com/news/bloodstock/1992-travers-winner-thunder-rumble-dies-at-26.
192. Stats courtesy of PedigreeQuery.com and Brisnet.com.
193. Old Friends website, "Thunder Rumble," www.oldfriendsequine.org/horses/thunder-rumble-631.html.
194. *Paulick Report*, "1992 Travers Winner Thunder Rumble Dies at 26."
195. Stats courtesy of PedigreeQuery.com and Brisnet.com.
196. Ron Mitchell, "Three-Time Grade I Winner Behrens Dies," BloodHorse.com, September 15, 2014, www.bloodhorse.com/horse-racing/articles/111913/three-time-grade-i-winner-behrens-dies; Nicole Russo, "Grade I Winner Behrens Dies at 20," *Daily Racing Form*, September 14, 2014, www.drf.com/news/grade-1-winner-behrens-dies-20.
197. Stats courtesy of PedigreeQuery.com and Brisnet.com.
198. Old Friends website, "Crusader Sword," www.oldfriendsequine.org/articles/crusader-sword-1985-2014.html.
199. Ibid.
200. Stats courtesy of PedigreeQuery.com and Brisnet.com.

201. Old Friends website, "In Memoriam," www.oldfriendsatcabincreek.com/our-horses/in-memoriam.
202. Stats courtesy of PedigreeQuery.com and Brisnet.com.
203. Old Friends website, "Moonshadow Gold," www.oldfriendsequine.org/horses/moonshadow-gold-630.html.
204. Stats courtesy of PedigreeQuery.com and Brisnet.com.
205. Old Friends website, "New Export," www.oldfriendsequine.org/articles/new-export-2001--2010.html.

CHAPTER 20

206. Old Friends, press release, http://archive.constantcontact.com/fs184/1102520673781/archive/1119791952252.html.
207. *Blood-Horse*, "Old Friends Opens Kentucky Downs Facility" (July 16, 2015), www.bloodhorse.com/horse-racing/articles/106296/old-friends-opens-kentucky-downs-facility.
208. Ibid.
209. Stats courtesy of PedigreeQuery.com and Brisnet.com.
210. Ibid.
211. Ibid.
212. Ibid.
213. Ibid.
214. Ibid.
215. Fonzi's Facebook page, www.facebook.com/Fonzi-at-Old-Friends-Kentucky-Downs-892254960869837.

CHAPTER 21

216. Interview with Tim Wilson, July 9, 2016.
217. A paper written by Tim Wilson, sent via e-mail, July 7, 2016.
218. Interview with Carole Oates, June 30, 2016.
219. Ibid.
220. Ibid.
221. Interview with Dr. Bryan Waldridge, July 9, 2016.
222. Ibid.
223. Ibid.
224. E-mail interview with Nick Newman, July 24, 2016.
225. Ibid.
226. Stats courtesy of PedigreeQuery.com and Brisnet.com.
227. E-mail interview with Nick Newman, July 24, 2016.
228. E-mail interview with Sally Faith Steinmann, August 17, 2016; Tom, her husband, is an artist whose website can be found at www.tomsteinmann.com.
229. Ibid.

230. Ibid.
231. Ibid.
232. Ibid.
233. Ibid.
234. Ibid.
235. Interview with Michael Blowen, July 3, 2016.
236. Ibid.
237. Interview with Ercel Ellis and Jackie Ellis, July 14, 2016.
238. Ibid.
239. Ibid.
240. Ibid.
241. Ibid.

CHAPTER 22

242. Interview with Tammy and James Crump, Thursday, June 30, 2016.
243. Ibid.
244. Ibid.
245. Ibid.
246. Ibid.
247. Ibid.
248. Interview with Michael Blowen, June 25, 2016.
249. Ibid.
250. Interview with Tammy and James Crump, Thursday, June 30, 2016.
251. Ibid.
252. Ibid.
253. Ibid.
254. Interview with Michael Blowen, June 25, 2016.
255. E-mail interview with Michael Blowen, March 28, 2017.
256. Ibid.
257. Ibid.

INDEX

ABOUT THE AUTHOR

*R*ick Capone has been a writer since the mid-1980s and worked as a technical writer at IBM, an editor/writer for a number of online publications and as the editor of *Coaching Volleyball* magazine for the American Volleyball Coaches Association. He is currently a freelance writer living in Versailles, Kentucky, just down the road from Keeneland. In addition, he has been published in a number of horse racing publications, both online and in print. This is his second published book. His first book, *The History of Old Friends: A Retirement Home for Thoroughbreds*, was also published by The History Press, in 2014. He lives in Woodford County, Kentucky, with his cat, Rascal, and is the co-owner of a beautiful, retired Thoroughbred at Old Friends, Miss Hooligan.

Portions of the proceeds from this book will go to the care of the Thoroughbreds at Old Friends.

If you would like information on how to donate to the farm, go to www. oldfriendsequine.org/how-to-help.html.